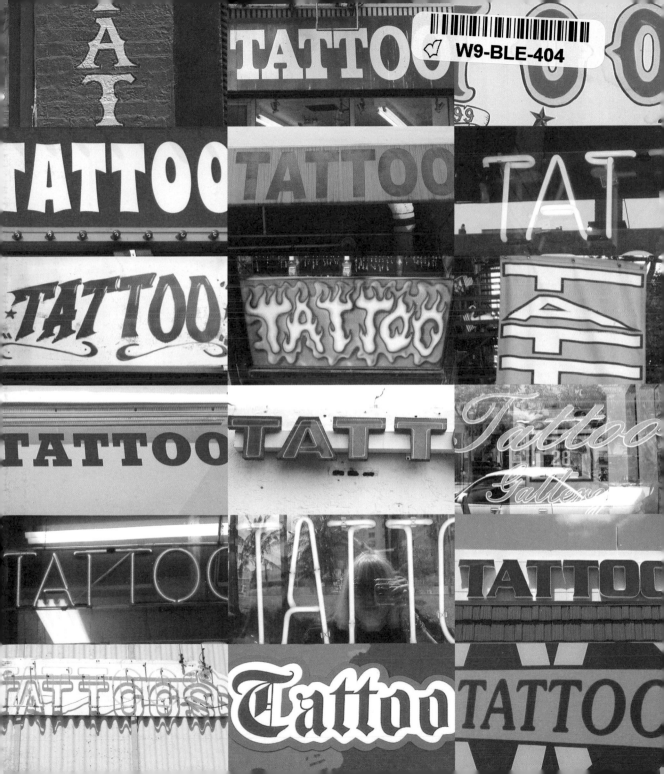

BODY TYPE

INTIMATE MESSAGES
ETCHED IN FLESH

TO BE OR NOT TO BE, THAT IS THE QUESTION
WHETHER TIS NOBLER IN THE MIND TO SUFFER
THE SLINGS OF OUTRAGEOUS FORTUNE,
OR TO TAKE ARMS AGAINST A SEA OF TROUBLES
AND BY OPPOSING END THEM

BODY TYPE

INTIMATE MESSAGES ETCHED IN FLESH

INA SALTZ

Abrams Image

New York

Editor: Tamar Brazis
Designer: Ina Saltz
Production Manager: Kaija Markoe

Library of Congress Cataloging-in-Publication Data
has been applied for.

ISBN 10: 0-8109-7050-3
ISBN 13: 978-0-8109-7050-2

Printed and bound in China
10 9 8 7 6 5 4 3 2 1

HNA
harry n. abrams, inc.
a subsidiary of La Martinière Groupe

115 West 18th Street
New York, NY 10011
ww.hnabooks.com

Dedicated to my parents, Irving and Josephine, who would have been so proud

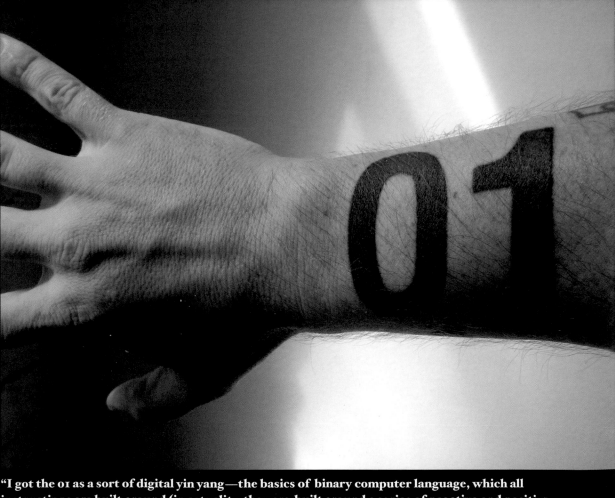

"I got the 01 as a sort of digital yin yang—the basics of binary computer language, which all instructions are built around (in actuality, they are built around a series of negative and positive voltages, but are represented as 0's and 1's in binary). I associated this with the delicate relationship of opposites which are illustrated through Taosim and are the basis of just about everything in the universe, according to Taoist thought."

CONTENTS

FOREWORD

IT BEGAN WITH A TRIP ACROSS TOWN on the bus, where I spotted an interesting-looking young man with an even more interesting and quite large tattoo on his right forearm; it spelled out "happy" in a typeface which I instantly recognized as Helvetica. The fact that it was in lower case and so tightly kerned that the letters were touching was especially intriguing to me as a designer and a typophile. I had never seen a tattoo quite like this one—sans serif! Not being in the habit of talking to strangers in New York City, I debated mightily before approaching him . . . but my curiosity finally got the better of me.

"Are you a graphic designer?" I asked. Why, yes, he was. "And would you mind if I took a photo of your tattoo to show my students? I teach typography at City College." No problem. I whipped out my digital camera and managed to get one shot and grab his proffered business card before I missed my stop.

That evening I uploaded the photo and went to the Web site on his business card to send the image with a proper thank-you message. Imagine my astonishment to find our entire conversation recounted on his blog!

As often happens when encountering something new, having seen one typographic tattoo, I now started to see them everywhere (it was August and a lot of skin was visible). Always searching for the next topic for my column in *STEP Inside Design* magazine, I seized upon the notion of documenting this "new" style of tattoo: unadorned words rather than images. Fortuitously, not far away, a huge tattoo convention was happening that

very weekend. I called my editor, who arranged for a press pass.

The circuslike atmosphere of the tattoo convention was an eye-opening experience . . . a hundred or more people being simultaneously tattooed; electric needles buzzing, drowned out by blaring rock music; tattoo competitions on the big stage; and a *very* eclectic crowd. I had no trouble finding examples of typographic tattoos for my article; in fact, I started to realize that this typographic tattoo thing was pretty widespread.

As I began to attend other tattoo conventions and follow the tattoo subculture, I noticed certain patterns. Most of the people I photographed were young, had gotten their tattoos recently, were educated in or already practicing in the creative arts, and were quite well-informed about their choice of typestyle. The texts of the tattoos were not at all what I expected; there were literary passages, poetry—even Shakespeare and Dante.

It became clear that the people who were getting these typographic tattoos were quite different from those who were traditionally associated with tattooing. I was surprised to find that no one had yet documented this trend. Having a lifelong passion for and involvement in the design and use of letterforms, I thought that a lengthy exploration of this phenomenon would be a worthy undertaking.

The journey of photographing, researching, and writing

Body Type changed me in ways I could not have predicted. To begin with, I developed a third eye that spotted typographic tattoos all over town. Second, if I saw any evidence of a tattoo, or I thought someone just might have one, I no longer hesitated to approach them: I became quite brazen! Almost all were eager to show me their tattoos, and lost no time in exposing body parts to give me a close-up look (however inappropriate that might have been at the moment).

Wherever I went (to a party, to the beach, to an opening, or some other professional event), I discovered a typographic tattoo or someone who knew someone who had one. Two nationwide reality television series about tattoos debuted almost simultaneously; new upscale tattoo Web sites proliferated, and a glossy and luxe tattoo magazine, *Inked*, packed with mainstream advertising, launched its premiere issue. Suddenly, there appeared to be a hyperactive public and media awareness of the tattoo world.

Although I had initially planned to write about the history and appropriateness of the letterforms used to convey a particular message (which is why I chose to include only Latin letterforms), I found myself drawn to the stories behind the tattoos, the individual and unique motivations for making a permanent commitment. (In the tattoo world, a tattoo is referred to as a "commitment"; the larger the tattoo, the more "serious" the commitment.) The stories dictated the structure of the book, divided by the themes of the tattoos: love and self-love, religion and politics, homage, celebration or exorcism, memorialization, exhortation, and remembrance. (In some cases, the tattoos fit into more than one category, but I have tried to honor the dominant intention of the wearer.)

As I interviewed my subjects, I discovered that their reasons for getting tattooed ranged from whimsical and impulsive to profound and deeply considered. Some tattoos were motivated by personal tragedy, others by joy. Whether tattoos were obtained to excise personal demons or to mark a rite of passage, these personal revelations fascinated me, and so the book became a different journey than the one I expected.

I decided the stories behind the tattoos needed to be told in order to understand why people chose to put themselves through the pain and suffering that even the simplest tattoos require. These narratives aroused my sympathy and compassion, subsuming my original intention simply to analyze typographic forms (although, where possible, I have identified typefaces by name). Certainly, the process of producing this book transformed my sensibilities, dispelled many of my stereotypical notions, altered the ways in which I interacted with others, and sparked insights about the human condition.

Because of my desire to tell the tattoos' stories in the voices of those who chose them, the captions for the tattoos are mostly written in the first person.

I have brought their stories and body art to light so that readers might consider their own beliefs and power to transform their bodies, souls, and perhaps even the world around them.

INTRODUCTION

TODAY'S TYPOGRAPHIC TATTOOS are a modern twist on an ancient and worldwide form of personal and cultural ritualistic expression. Declarations of love or hate, political and social commentary, satire, personal mottoes and beliefs, religious devotion, logotypes, homage to public figures and entities, beloved song lyrics, or just plain fun: Typographic tattoos provide an indelible and ineradicable commitment. These "intimate messages" are the ultimate tribute to words and letterforms, acquired with pain and bloodshed.

Although substantial tattoo subcultures still exist (prison, biker, military, fraternity, sports teams, and gang tattoos) there is a newly defined stratum of the tattooed: affluent, culturally aware, sophisticated, and highly educated young people who are choosing to adorn themselves with tattoos consisting of typographic messages rather than imagery. The traditionally tattooed paved the way for these tattooed newbies, who envision the typography of the tattoo as the image itself. This book offers a unique graphic depiction of this significant and pervasive pop-culture phenomenon.

What's new is the sophistication and awareness of tattoo design. Words serve as literal text as well as figurative art, revealing intimate beliefs, life's challenges, and value systems. Those pictured in these pages have chosen to set themselves apart, to mark their individuality, and, at the same time, to join a tribe of kindred spirits, to bond with others who have similarly altered their bodies.

Many new tattoo artists are often design school grads with a broad knowledge of typographic choices. They have studied letterforms, and have been trained in the nuances of letter design. Both the tattooed and those tattooing them are responding to our visually driven culture. Patrons of tattoo parlors, sensitized to the differences among various typefaces by the availability of many fonts on their computers as well as by our highly graphic and typographic daily media experiences, often provide their own predesigned messages. They understand the implications of their choice of lettering style—the forms of the letters themselves have the power to amplify the meaning of the text.

The typographic tattoo trend described is being driven in part by the new elite: celebrities in the world of sports, film, modeling, and music who have gotten "message" tattoos and made them even more socially acceptable. These boldface names include Angelina Jolie, Johnny Depp, David Beckham, Eminem, Christina Aguilera, Lindsay Lohan, Diddy, Jon Bon Jovi, Nelly, Charlie Sheen, Tommy Lee, Melanie Griffith, Pink, the Red Hot Chili Peppers, Kanye West, Sean Penn, Dennis Rodman, and almost every other player in the NBA.

A flourished script style

Blackletter ("gothic")

In the style of "Sailor Jerry"

Tattoos are enjoying a tremendous resurgence, and they have evolved from rebellious and antisocial statements to mainstream social acceptability. Tattoos are no longer a bar to employment at even the highest levels, and recent polls show that 16 percent (41 million) of all Americans are tattooed. Many of your friends and neighbors are "sporting ink" (as it is popularly known); though you might not know it if the tattoos are in "private" places.

A Harris Interactive poll found that 36 percent of twenty-five- to twenty-nine-year-olds have tattoos. The Mayo Clinic found that 23 percent of university students had one to three tattoos. And even if you don't have a tattoo, you might have fantasized about getting one. Maybe you're simply a voyeur—people are fascinated (often simultaneously attracted and repelled) by tattoos. So perhaps it is not surprising that there is such widespread interest in tattoos and tattooing.

TRADITIONAL TATTOO LETTERING is generally a variation of simple capitals, using a single or mono-line; a script-based style; or a "gothic" (blackletter) form. A popular twentieth century lettering style, military in its origins and usually attributed to tattoo artist Norm Collins, is "Sailor Jerry" lettering, consisting of an outline with filled-in double-stroke verticals. Handlettered and customized versions of lettering styles often reveal the personality of the tattoo artist, just as a person's handwriting expresses his individuality. These forms may be embellished with elaborate flourishes, a common companion in the tradition of calligraphy and the lettering arts.

Newer forms of tattoo lettering are based on typefaces widely available on computers and online. These fonts have very specific shapes, and, though they were not designed to be used for tattoos, many adapt well, as long as the artist is skilled enough to reproduce the design details faithfully.

A lettered tattoo is no easy task for the tattoo artist, though it may appear simpler than an elaborate pictorial tattoo. In fact, many artists do not take the trouble to document their typographic work, believing that lettering requires less "talent" on their part . . . however, nothing could be further from the truth. Just as type design is a profession which requires tremendous skill and training, with an eye for harmony and subtlety, the rigors of tattooing letterforms quickly expose the artist's level of expertise, since there is little room for error.

Some typographic forms are especially difficult to execute well: the narrow, compressed, sans serif forms of the frequently tattooed Harley-Davidson logo, for

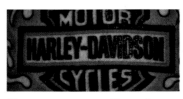

Narrow, compressed lettering

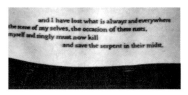

Small, detailed roman lowercase

Serifed roman caps; a lengthy text

example. The spaces inside the letters (counter spaces) as well as the spaces between the letters (kerning) cannot be allowed to fill in with an errant slip of the needle. Small forms with serifed details are also a challenge, as the serifs and stroke weights must be precise and consistent in order to appear cohesive. The smaller the letterforms, the more difficult it is for the artist to stay true to the design. Longer texts are also more difficult, since they require the ability to sustain a consistent typographic tonal weight, or "color," throughout the passage.

Tattoo artists can seldom afford to specialize in typographic tattoos, but some become known for their skill in tattooing text. In New York City, Stephanie Tamez is the artist most in demand for typographic tattoos. In Chicago, it is Nick Colella. BJ Betts, a tattoo artist based in Delaware, has also devoted himself to typographic tattoos, and has written the *Custom Lettering Guide* for tattoo artists who want to perfect their lettering skills. BJ's advice ranges from creating a contour guideline for banners to techniques for adjusting the wordspacing and letterspacing. What makes his book different from other typography books? The special considerations that must be taken into account: the skin's changing elasticity as it ages, and the fact that tattoos can fade and bleed (spread) over time. Consequently, BJ suggests that very small text be avoided, and that centering a tattoo can minimize the appearance of sagging later on. Symmetrical tattoos create a sense of balance.

Both artists point out that it is critical to take into account the shape of the body part as well as the shape it will create as it moves; a well-designed tattoo will follow these natural shapes. This can be difficult in the case of longer passages that need a consistent baseline (the line where the type "sits"); type is generally read along a straight line, but the body has no true straight lines.

In the case of text tattoos that wrap around a body part, such as an upper arm or an ankle, careful planning is necessary to ensure that the quote fits around the circumference perfectly, while maintaining consistent height, stroke width and weight, letterspacing, and wordspacing.

THE TECHNIQUE OF TATTOOING has changed very little over the course of its history. Various pigments are forced under the skin by means of a pointed object. The process involves a certain level of craftsmanship in applying the correct amount of the pigment, and determining the proper level of dermal penetration to avoid scars or ruptured blood vessels. In early times, tattooing instruments consisted of sharpened sticks, pieces of ivory, or bone. Pigments might have been soot, ash, plants or other organic materials, or earthen minerals.

The electric tattooing machine, patented in 1891 by Samuel O'Reilly, was based on Edison's electric pen, which punctured paper with a needle point. That model is still the basis for today's tattoo machines.

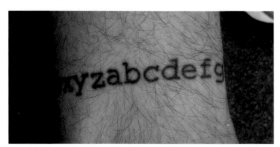

Circumnavigating an ankle with the alphabet

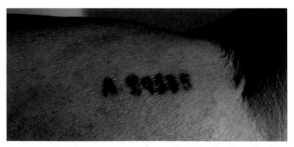

A concentration camp survivor; the A is for Auschwitz

When the skin heals over the wound, the tattoo is "sealed" and permanent. (Even with current laser-removal techniques and plastic surgery, it is virtually impossible to remove all traces of a tattoo; some scarification will remain).

THE RICH HISTORY OF TATTOOS stretches back at least five thousand years. In 1991, the five-thousand-year-old frozen corpse of the so-called "Ice Man" was discovered on an Italian mountaintop and his well-preserved skin clearly bore fifty-seven tattoos. In Egypt, mummified remains from approximately 2000 BCE revealed tattoos, and in Japan, clay figurines dated 3000 BCE and older were found to have faces painted to represent tattoos.

In almost every ancient culture, and on every continent, tattooing played a role, from the tattooing of slaves and criminals in ancient Rome, to Incan and Mayan tattoos representing signs of courage.

In Pacific cultures, tattooing had great historic significance. In the ancient world, Polynesian tattooing was considered the most elaborate and skillful. When the explorer Captain Cook brought back tattooed Polynesians to England, tattooing became popular there. In 1862, the prince of Wales, who later became King Edward VII, received his first tattoo. When he was tattooed before ascending to the throne, many British aristocrats got tattoos, often of their family crests. Others in the social elite had tattoos: the Furstenbergs, the Vanderbilts, Emperor Wilhelm II, and Lady Randolph Churchill.

In the Western world, after the turn of the century, the upper classes began to turn away from tattooing and the practice became associated with the military (who often commemorated their tours of duty or their ships, planes, or units), circus "freaks," and fringe types—bikers, prostitutes, juvenile delinquents, prisoners, gang members, and the like. Typography could often be found in the ribbon or "banner" area of a tattoo, "Mom" being the most common tribute to a loved one. However, in general, the text was subsidiary to the image.

One horrific exception was the tattooing of numbers on concentration camp inmates. The Nazis were well aware that Jewish custom and law prohibited tattoos, and the tattoos thus contributed to the dehumanization and humiliation of the prisoners. Less well known is the fact that SS soldiers had their blood type tattooed on their forearms, in the event of a medical emergency. (This practice continues today among some military groups.)

In the late 1960s, tattoos became a popular form of antiestablishment and anarchistic expression for disaffected college students, paralleling the social and sexual revolution roiling America. Charismatic tattoo artists such as Ed Hardy, Lyle Tuttle, and Henk Schiffmacher developed followings and further popularized the form.

In the intervening years, the popularity and social acceptance of tattoos has exploded. But the driving force behind today's prevalence and "normalization" of tattooing is unquestionably the new cultural aristocracy: film stars, the kings and queens of rock, sports heroes, celebrities, and artists of every persuasion. The tattoo world has now become the ultimate in chic. (One disturbing spin-off: young people "selling space" to advertisers whose logos are then tattooed on their bodies.)

This book is a visual adventure into the complex and vivid realm of contemporary typographic tattoos. These texts provide a permanent record of life's passages: emotional, physical, and spiritual. They reflect who we are, who we want to be, and where we aspire to go.

Tattoos may be conceived to shock, impress, titillate, or amuse, and ultimately to communicate a message of self, of style, and of sentiment. These personal messages are deeply permanent, perhaps more permanent than some of the feelings that inspired them. Still, we cannot help but admire such a strong commitment to the printed word and to the typographic shapes that give it voice.

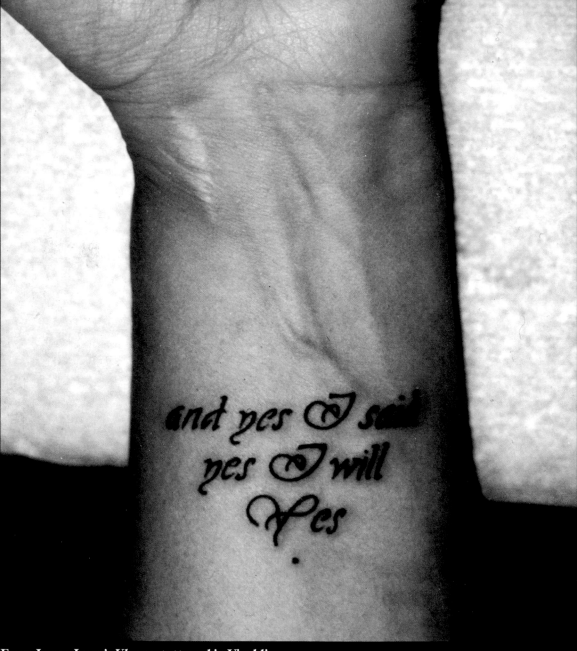

From James Joyce's *Ulysses,* **tattooed in Vivaldi**

ONE:
LITERATURE, POETRY, & LYRICS

WE'VE ALL BEEN INSPIRED by beautifully written words, whether they are prose, poetry, song lyrics, or epigrams. Our favorite words are texts which resonate with us personally— which speak deeply to something within us, based on our own intimate emotions and experiences. From Dante to Shakespeare, from Whitman to Vonnegut, our world is rich with texts that bring us to a deeper understanding of ourselves, our world, and the human condition.

Although it is said that imitation is the sincerest form of flattery, an even more significant tribute is to make these words a part of our own being, to etch them immutably into ourselves, into our skin. The authors of these words might be surprised to learn that the products of their creative imaginations have been so closely taken to heart . . . perhaps they would be flattered by the courage of those who have committed these words not only to memory, but to flesh.

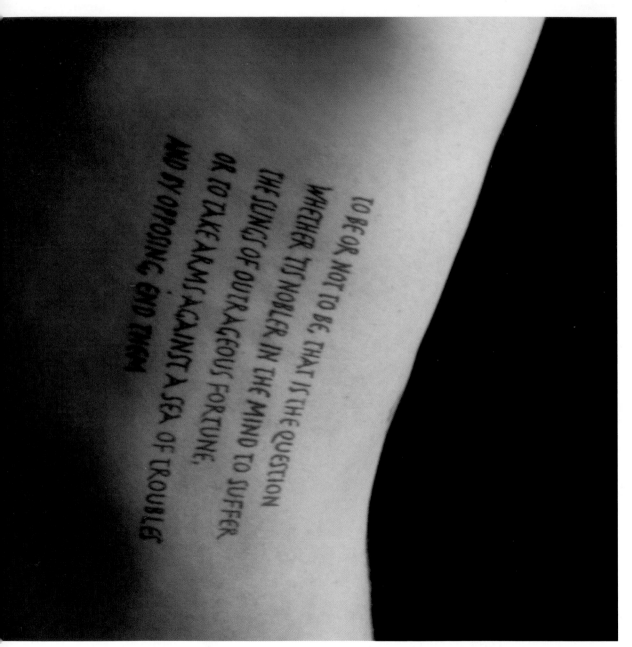

From Shakespeare: Hamlet's soliloquy. This page and opposite page: "All of my tattoos stem from my issues with my deeply rooted Catholic upbringing . . . and from the realization that I was in a dark place in the middle of my life."

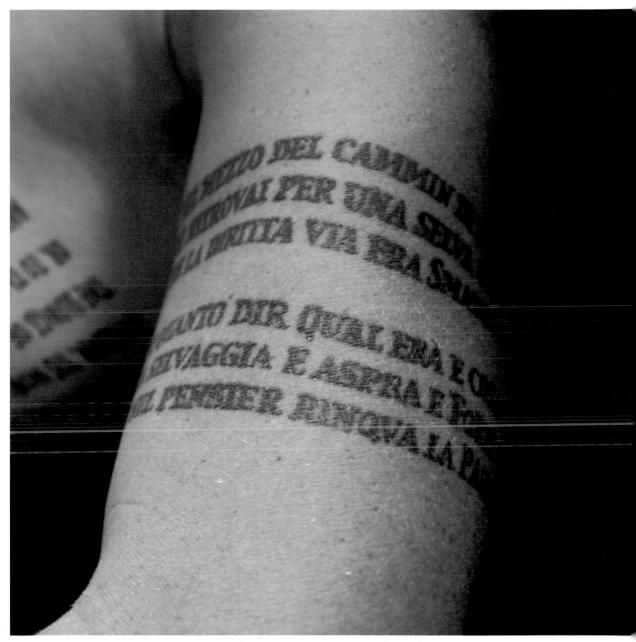

From Dante's *Inferno*: "When I had journeyed half of our life's way, I found myself in a shadowed forest . . ." These two tattoos are exquisitely rendered with precise regard for the typographic forms and with tightly consistent letter- and wordspacing.

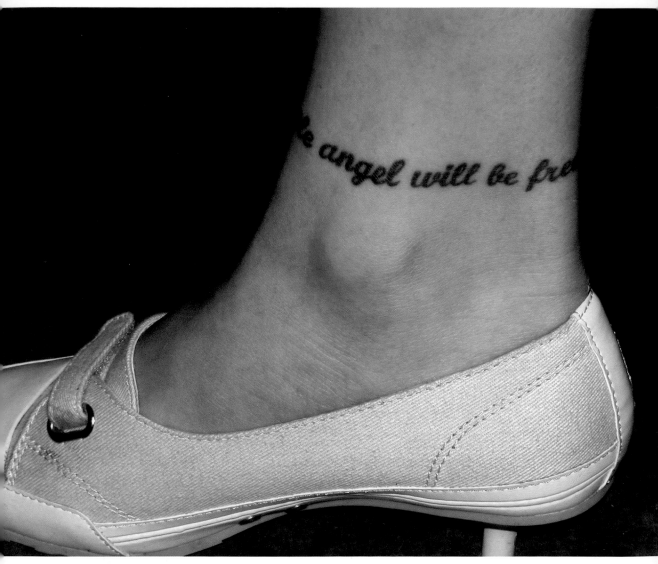

" 'In hope this little angel will be free' is a lyric by the band Boy Sets Fire. It is a saying that I identify with."
This strong and simple script typeface works well as an ankle circlet.

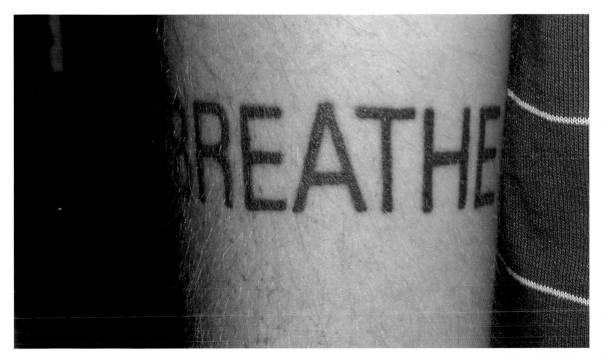

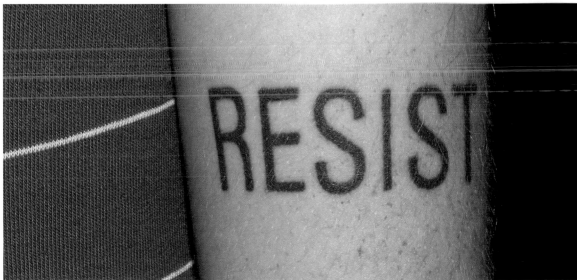

"These words are from my favorite song from an old hard-core punk rock band called Hoover . . . they are in Univers 47, one of my favorite typefaces. My friend who is a graphic designer helped me kern the letters. The words are to remind me, as I have become an adult, to resist the urge to become complacent and give up on my ideals."

Bottom wrist: " 'Fear is the mind killer' is the most well-known phrase from Frank Herbert's classic sci-fi work, *Dune.* I wanted it in a futuristic-looking typeface."

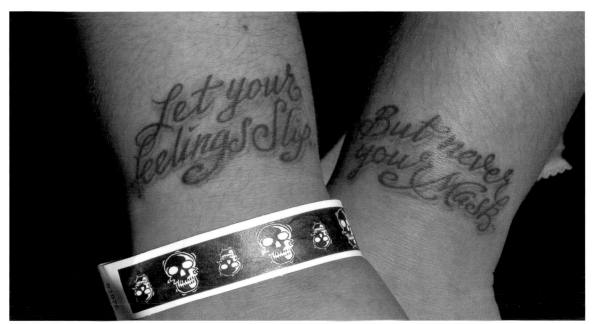

"This is from the song 'Born Slippy' by Underworld; it is on the *Trainspotting* soundtrack . . . it's a quote I live my life by."

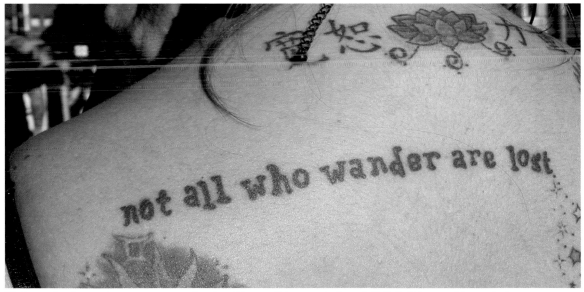

"I chose the font on my computer and printed it out. It's a quote from J. R. R. Tolkien, and it reminds me that I am wandering through this world, but I know right where I'm going."

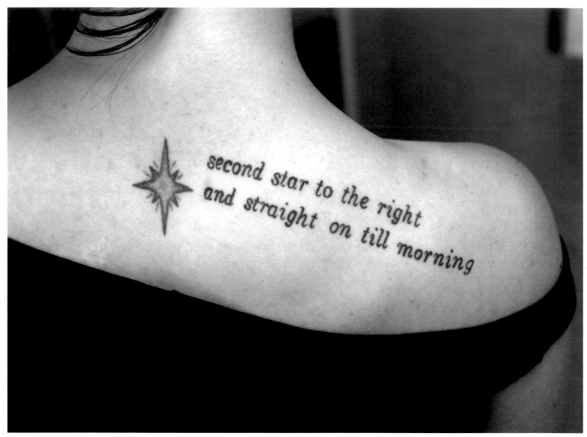

"The quote from *Peter Pan* means a lot of different things; the reason I got it was so I could find my way back to Neverland . . . meaning that I never want to lose the part of myself that has a childlike wonder."

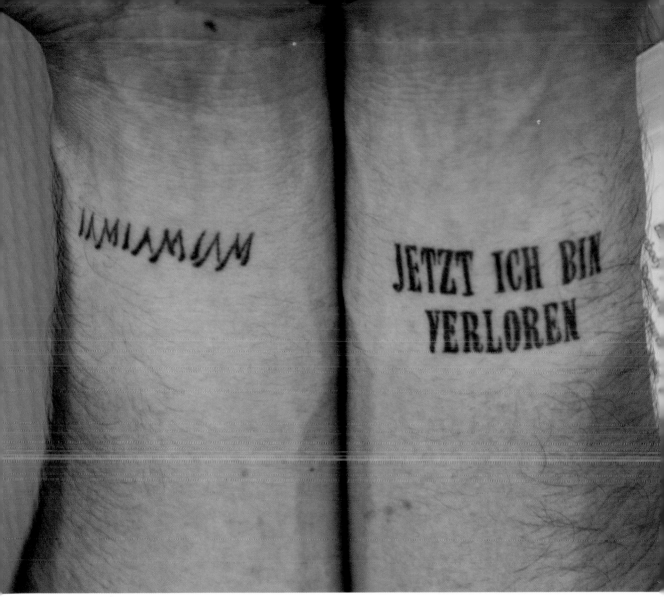

"IAMIAMIAM is a line from Sylvia Plath's *The Bell Jar.* I designed the font, and I don't cross my capital A's. On my right wrist is a Mars Volta (alt rock band) lyric which I translated (very poorly) into German. I'm a fan of Kafka, and both his writing and Mars Volta songs have a similar modernist theme/mood to them, so that's the reason for the German. It translates to 'Now I am lost' but to be grammatically correct in German, the 'bin' should have come before the 'ich' . . . alas, it is too late for that." The tattoo on the left is a personal design; the typeface for the tattoo on the right is Cheltenham Bold Extra Condensed.

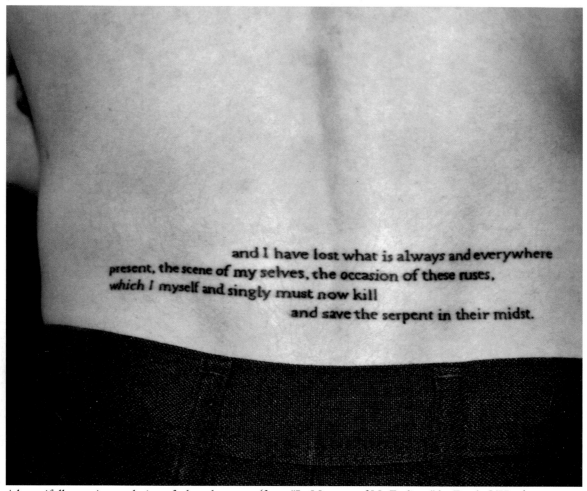

A beautifully precise rendering of a lengthy quote (from "In Memory of My Feelings" by Frank O'Hara) in a lowercase serifed typeface based on Caslon.

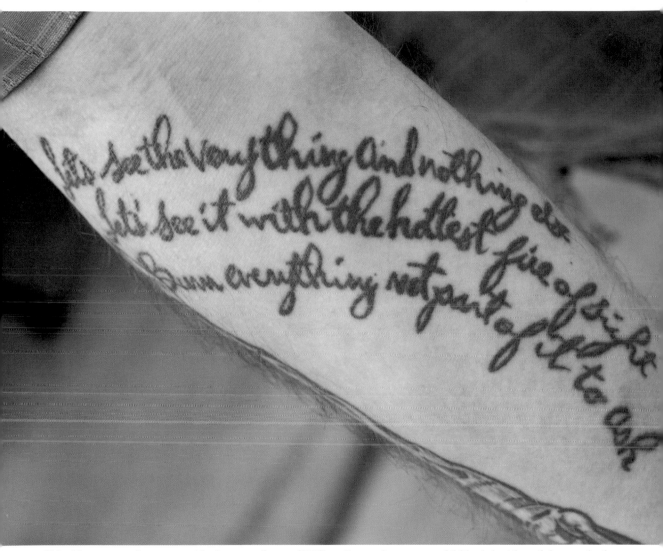

"I had long wanted a tattoo with the text of one of Wallace Stevens's poems, and I liked the idea of the text looking handwritten, coming out of a fountain pen. Choosing the text was difficult, since Stevens has a large body of work. After much hand-wringing, I settled on these three lines from 'Credences of Summer,' a favorite of mine. I picked these lines because they can stand on their own, and still capture what I find most appealing in Stevens's work: the rhythm and cadences, the willful obscurity, the insistent and slightly surreal images."

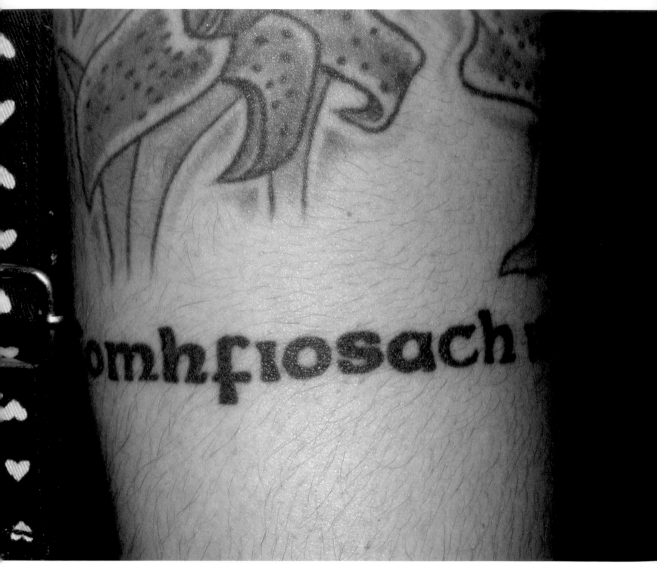

"The text is a line of dialogue from the movie *Being John Malkovich*: 'Consciousness is a curse; I think, I feel, I suffer.' I had it translated into Gaelic because I have an Irish background. I've been through so much transition —inside and outside—that the quote has been appropriate for so long."

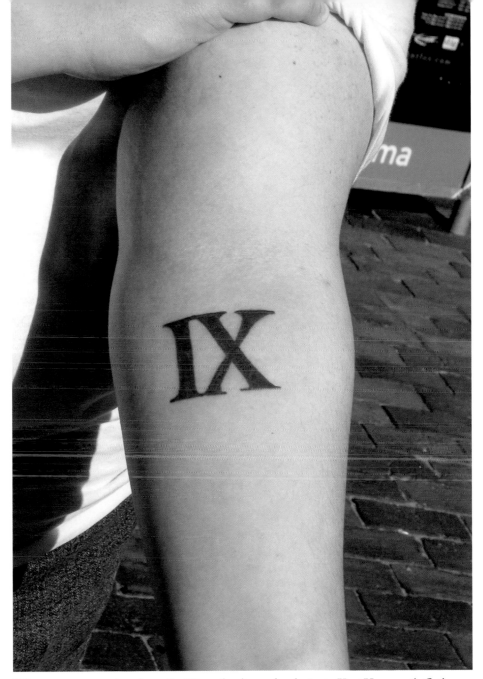

"The roman numerals refer to Ice Nine, the doomsday device in Kurt Vonnegut's *Cat's Cradle*, and it was also the number of Ted Williams from the Boston Red Sox, who was a childhood friend of my grandfather's."

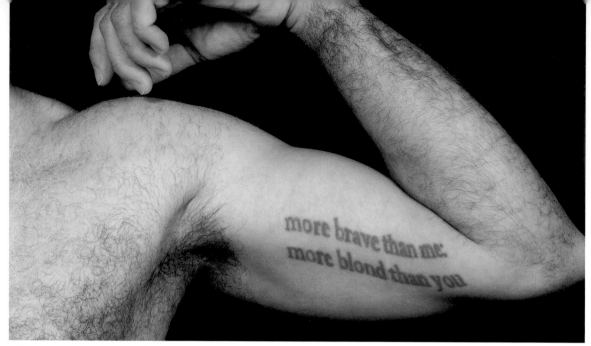

(These four tattoos are on the same person.) "The quotes I have chosen are from masters of twentieth-century writing in English. I am a reader, these works are out in the world, and they spoke to me such that I went to unusual lengths never to forget them. Together, they articulate how I would be in the world. These words end e. e. cummings's *I sing of Olaf glad and big*; the typeface is Dante. Purple, green, and blue are strength colors. Red is passion."

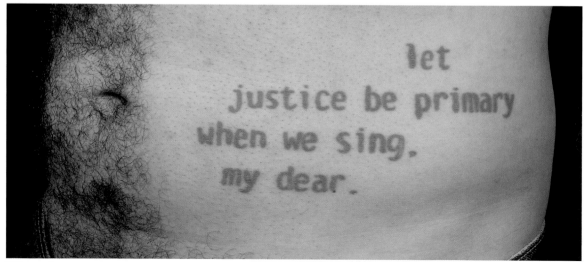

"This is from Hayden Carruth's *Another*; it honors his lineation, as does the cummings tattoo."

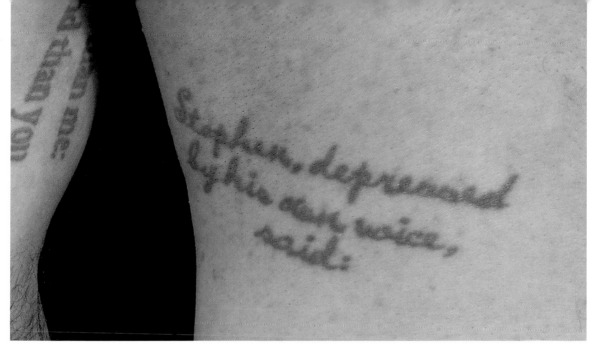

"This is from the first chapter of James Joyce's *Ulysses*. The direct antecedent of my tattoos is probably the novelist Harry Crews, one of my fiction writing instructors . . . Harry has cummings's 'how do you like your blueeyed boy Mister Death' on his upper arm —in the macho spot."

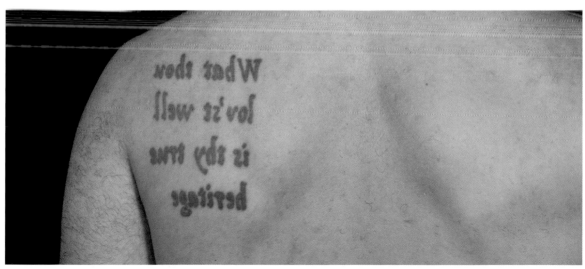

"This is reversed on my trapezius, so I can read it in the mirror . . . it is from Ezra Pound's 'Canto LXXXI.' "
I set the lead type in Arrighi."

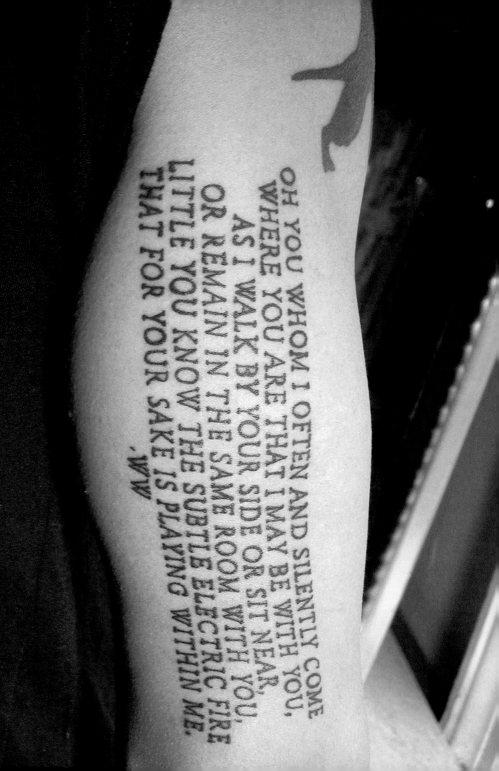

OH YOU WHOM I OFTEN AND SILENTLY COME
WHERE YOU ARE THAT I MAY BE WITH YOU,
AS I WALK BY YOUR SIDE OR SIT NEAR,
OR REMAIN IN THE SAME ROOM WITH YOU,
LITTLE YOU KNOW THE SUBTLE ELECTRIC FIRE
THAT FOR YOUR SAKE IS PLAYING WITHIN ME.
.W

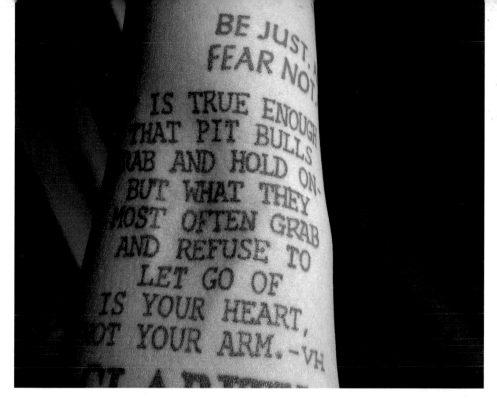

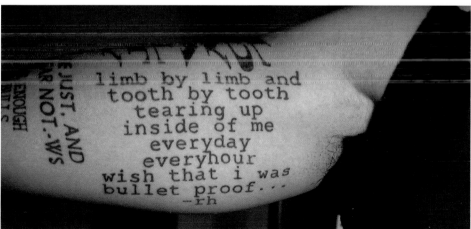

"My whole arm is based on American pit bull terriers as a breed . . . every quote is linked back to that; I had pit bulls growing up. VH (top) is Vicki Hearne, a well-known animal trainer, philosopher, and writer. WW (left) is Walt Whitman. 'Be just and fear not' (above) is from Shakespeare's *King Henry the Eighth*. The quote below the word 'loyalty' is from a song lyric by Radiohead. My texts are set in Courier, New York, and New Century Schoolbook; these are the fonts that I felt were me and I wanted them to be clear enough to read."

Above: "This is the last line of philosopher Ludwig Wittgenstein's *Tractatus Logico-Philosophicus*. The translation is 'What we cannot speak about we must pass over in silence.' It is tattooed in Helvetica Neue Bold Condensed."
Opposite: This line (also the title) from a Dylan Thomas poem is broken and rendered in expressive typography, to enhance the meaning of the text. The artist was given complete freedom in the design.

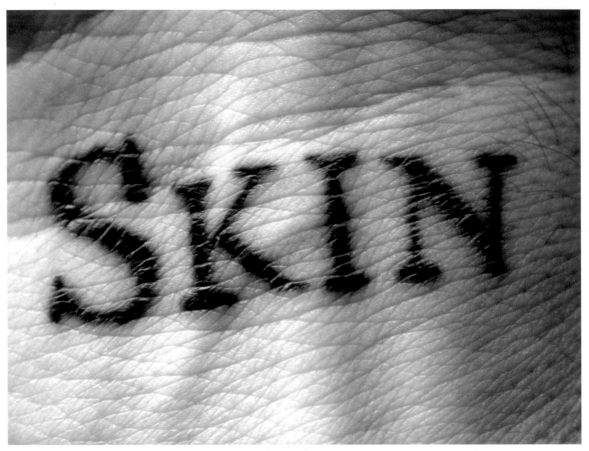

A unique literary work of fiction (2,095 words) by the writer Shelley Jackson entitled *Skin* is being published "in an edition of one" (meaning one word at a time) by being tattooed on 2,095 separate individuals. Jackson began the project by having the title of her work tattooed on her wrist in the typeface Baskerville. Jackson then placed a call for participants in the literary magazine *Cabinet*. Almost all of the words have already been assigned and most have been tattooed. Participants in Jackson's project are instructed to have their assigned word tattooed in black ink in "a classic book font" (which Jackson clarifies on her Web site). The following tattoos are a small sampling of those who have answered Jackson's invitation to "become" a word.

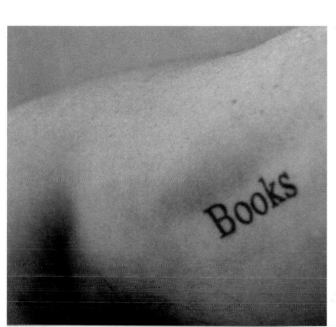

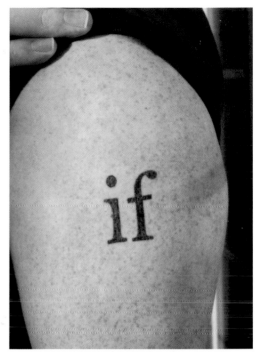

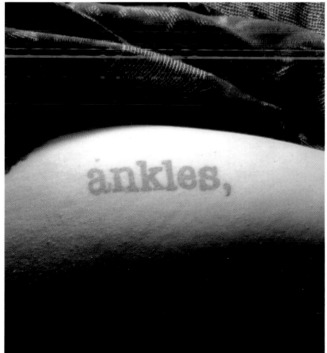

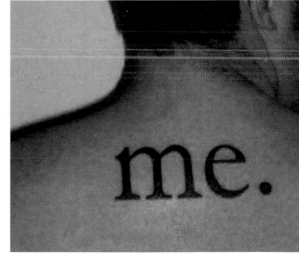

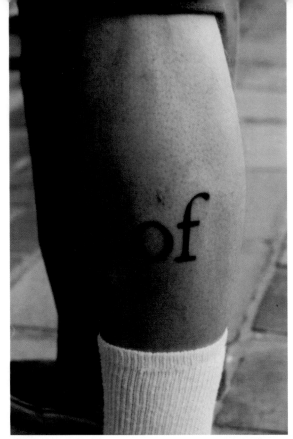

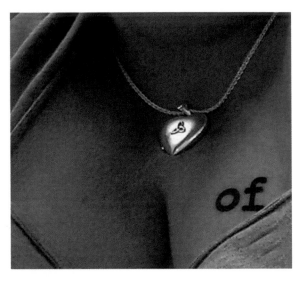

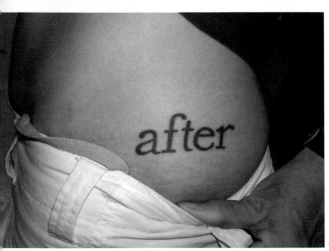

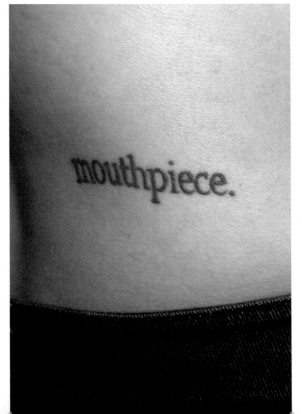

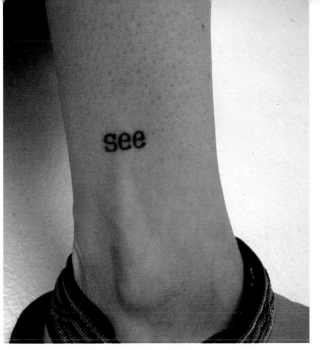

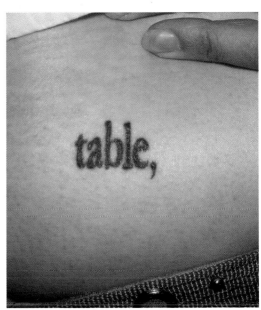

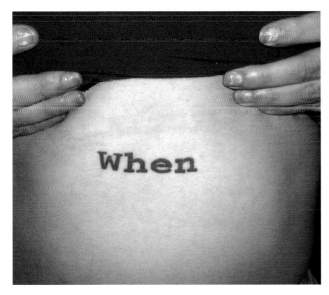

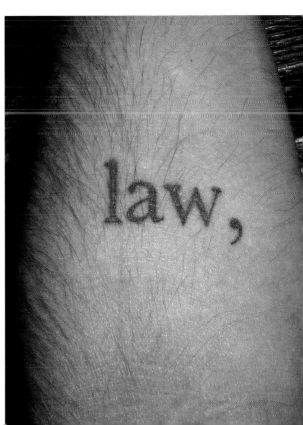

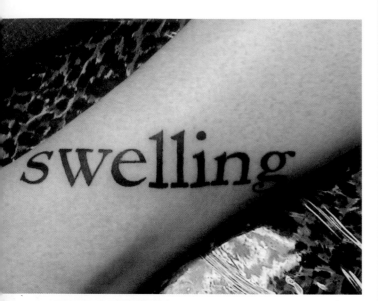

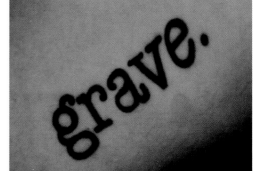

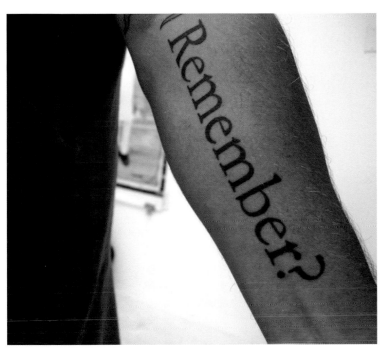

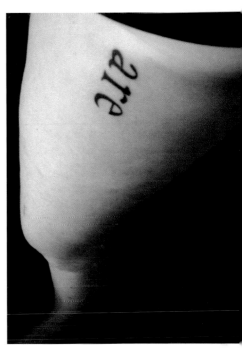

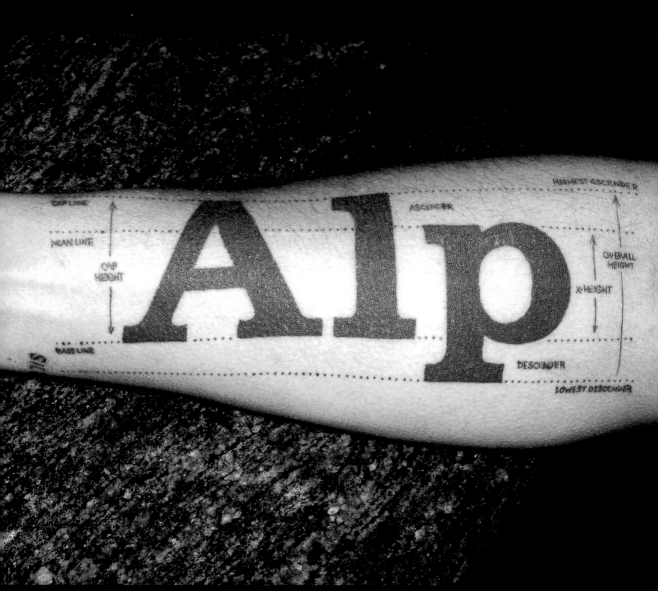

CAP LINE

MEAN LINE

ASCENDER

HIGHEST ASCENDER

CAP
HEIGHT

OVERALL
HEIGHT

X-HEIGHT

BASE LINE

DESCENDER

LOWEST DESCENDER

This art director chose to reproduce a type-specific diagram from a nineteenth-century type book; the letterforms are a precursor to the typeface Clarendon.

TWO: TYPOGRAPHY

IN THE WORLD OF DESIGN, there is a distinct subculture of those who are deeply passionate about typographic forms. (Confession: I am one.) The letters that, in the form of words, communicate the entirety of our civilization from generation to generation are themselves the products of many hundreds of years of development. As type designer Berthold Wolpe wrote: "Letters, those seemingly commonplace little signs taken for granted by so many, belong to the most momentous products of creative power. They are the abstract refinements of creative imagination, full of clarity, movement, and subtlety."

Is it any wonder, then, that some of us who devote our lives to the design, study, and use of typography have chosen to declare our love of letterforms with typographic tattoos? For those who do not exist in this character-driven world, the passion for letterforms may seem arcane. Another motivation for these tattoos, then, might be to educate nonbelievers, to make them understand that little matters more to us than the beauty and functionality of typography.

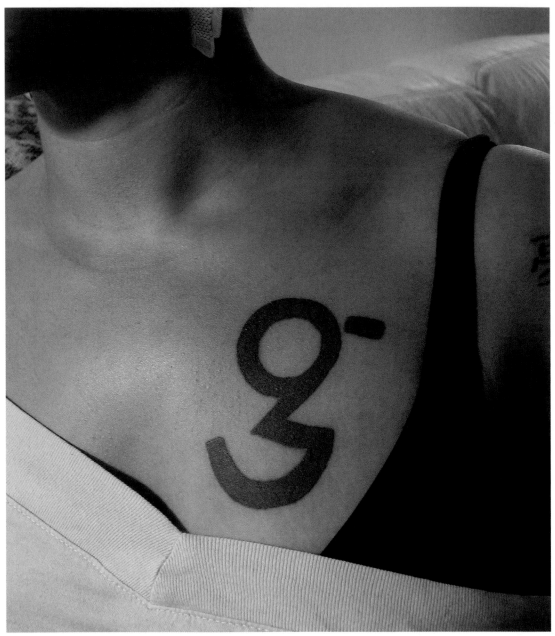

"This tattoo is from Paul Renner's early design for the typeface Futura; I love the shape of the lowercase g."

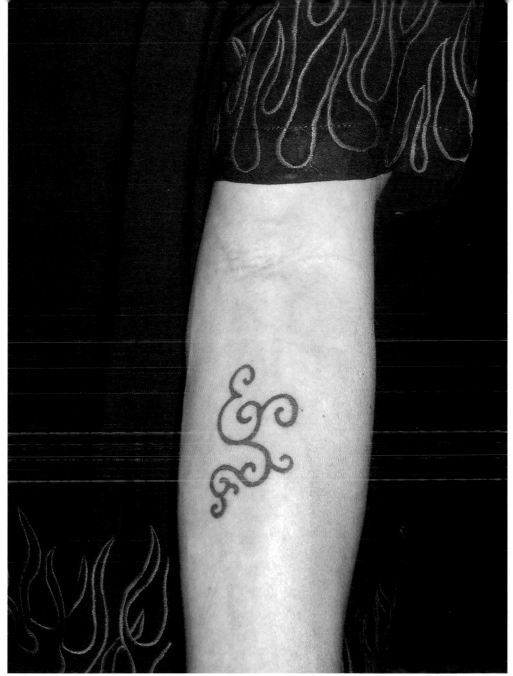

This Brazilian type designer and his brother designed a curly display typeface called Samba; his tattoo is of the ampersand from his typeface.

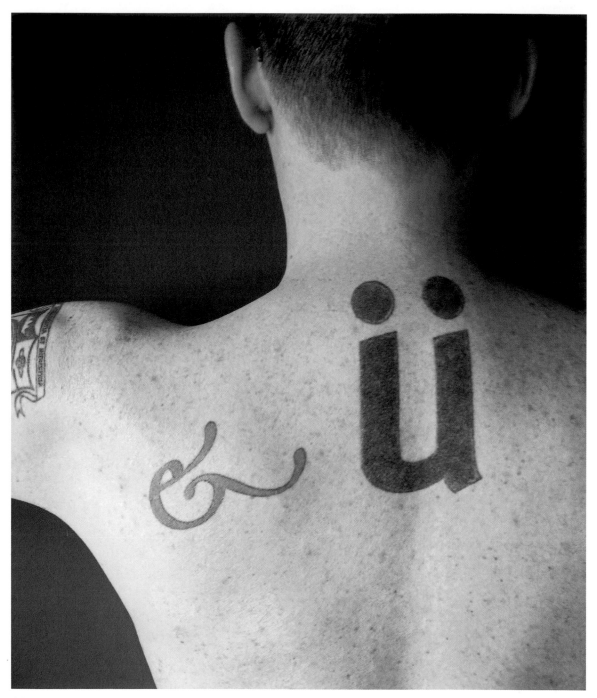

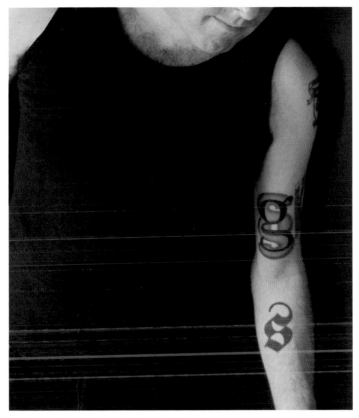

This graphic designer celebrates letterforms one at a time with an ongoing series of tattoos based on letterforms that he thinks are beautiful. The lowercase g in Baskerville is superimposed on a section symbol in Champion. The s is from the typeface Fette Fraktur. The ampersand is from Hermann Zapf's typeface Poetica, and the ü is Eric Spiekermann's Meta. "From a visual standpoint, I'd been wanting something big, black, and smooth-edged, and I liked the idea that the dots of the umlaut would be visible above the neck of a T-shirt."

"I think of the ampersand as having no meaning without two things to join . . . this one represents the joining of me and my wife, two very different individuals. When we were newlyweds, on the anniversary of our meeting I gave her a charm of an ampersand; and I got this tattoo. It's like the wedding ring that doesn't come off. I'm a bagpiper and a biker, so my tattoo is often visible on my leg; I get a lot of inquiries about it. I chose Times New Roman on my computer, printed it out and blew it up for the artist."

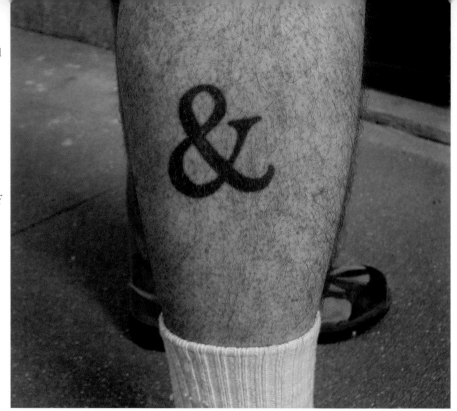

"I got this ampersand when I was twenty-five; it is an iconic mark, like an anchor, but it related to my writing aspirations."

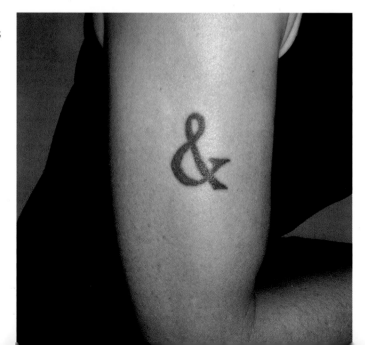

46

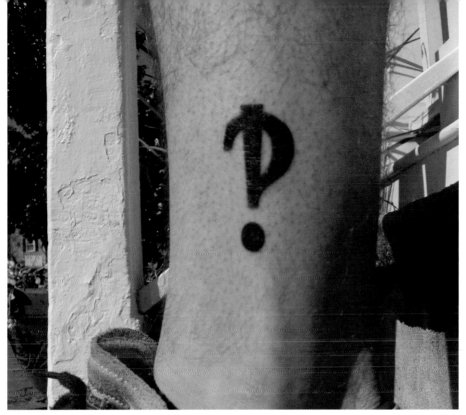

The interrobang is a character or glyph that combines the exclamation point and question mark. "My interrobang was used for a design project at school that investigated the reintroduction of the interrobang into the American vernacular. For my tattoo I chose FF Avance, a typeface designed by Evert Bloesma in the Netherlands."

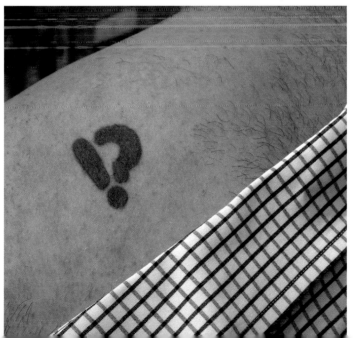

This type designer chose to get a tattoo of the interrobang from a typeface he designed while still in school; it is called Fritz, named after his nephew, who was six years old at the time.

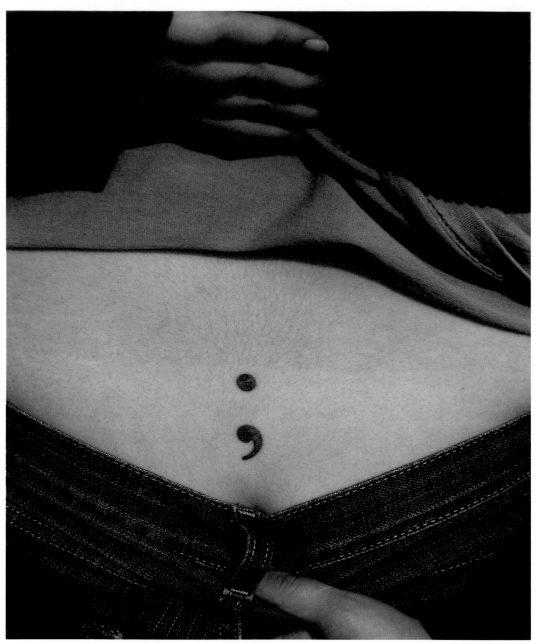

"I am a writer and I love punctuation; the semicolon is my favorite punctuation mark. It is special; you are not supposed to use it that often. I printed it out in Times New Roman from my computer and brought it to the tattoo parlor in the exact size I wanted."

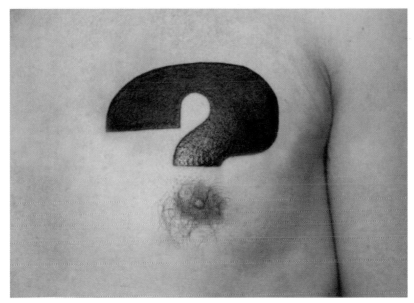

"I am a tattoo artist and I studied typography. When I designed this question
mark, I based it on a bold extended Egyptienne,"

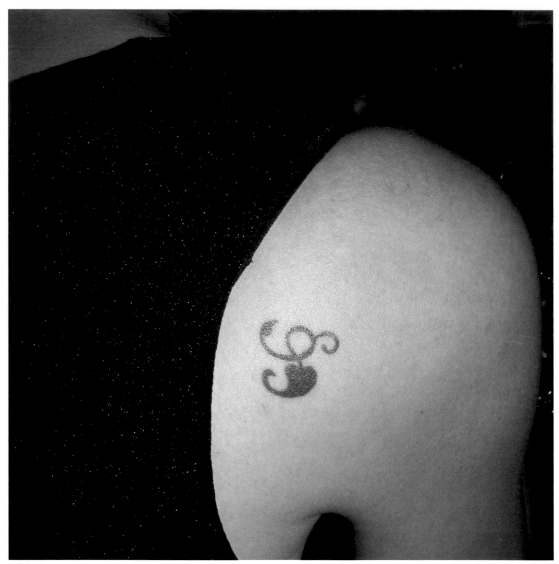

This design professor's tattoo is a decorative typographic ornament called a fleuron. "I found it in a book published in 1924 and printed in Prague (*The Fleuron: A Journal of Typography*); it is from the title page, designed by V. H. Brunner. For me, this character melds text, content, art, and design together into one simple, classical, and elegant graphic element."

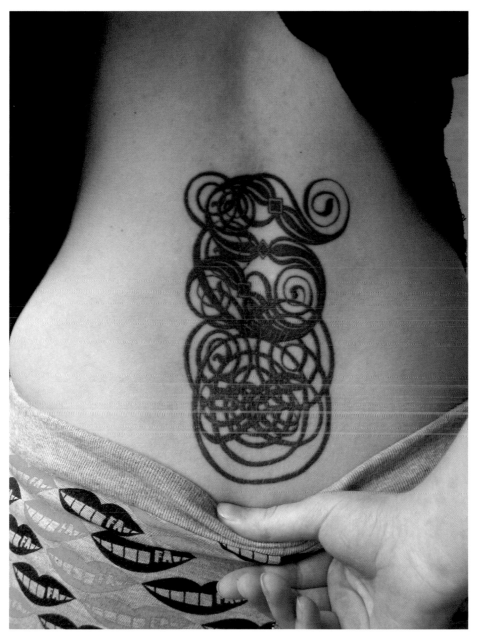

"I am a graphic designer; I collect typography clip art books. My tattoo of the flourished letter S (my initial) is based on a sample of German calligraphy from the sixteenth century. I always wanted a tattoo and I knew I'd be happy with this one over a long period of time."

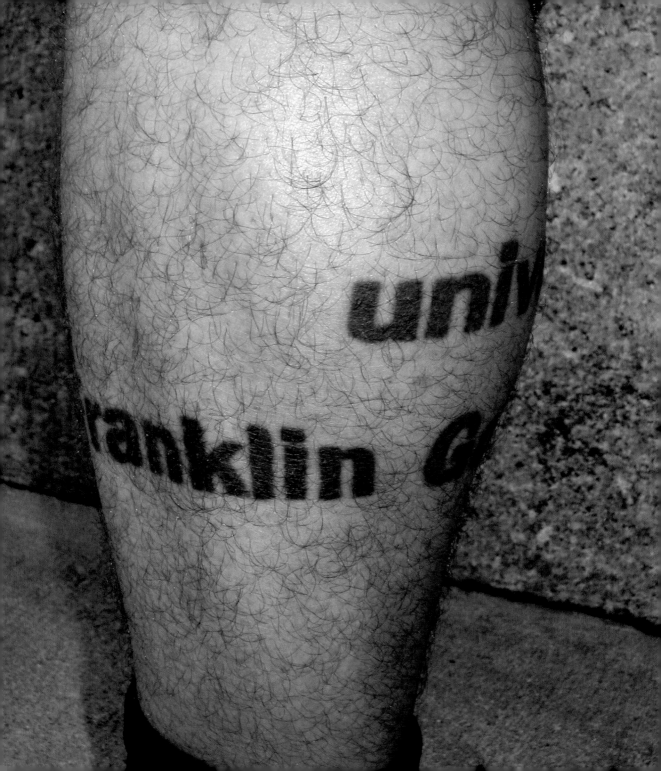

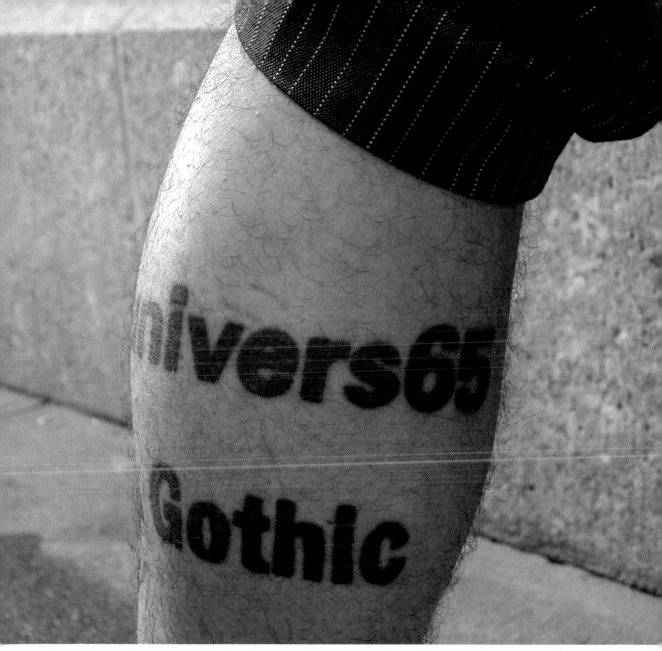

This art director chose to get tattoos in the names of the actual typefaces. "One reason I was attracted to graphic design was typography; I was very interested in Kanji. I also have a strong connection to Basel. These typefaces are favorites of mine (Franklin Gothic No. 2 and Univers 65). Next I am planning on a tattoo of Clarendon."

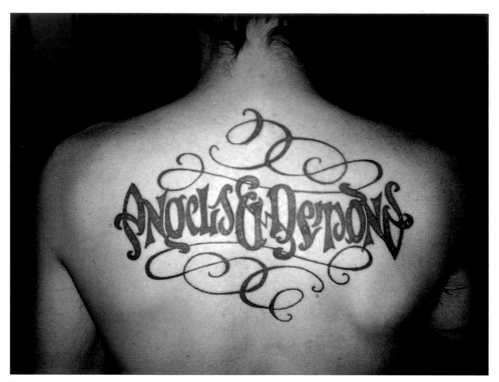

Symmetrical ambigrams are words that are designed to read the same whether right side up or upside down. The leading designer of ambigrams is John Langdon, who created this one for the cover of Dan Brown's best-selling book *Angels & Demons*.

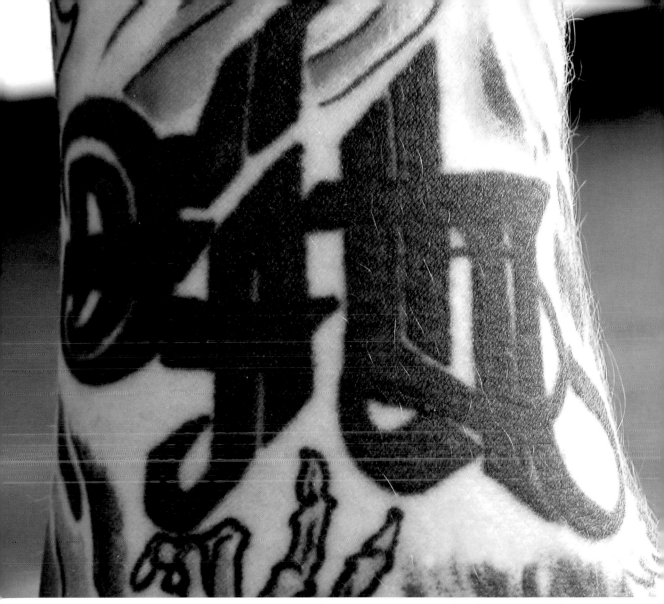

This is a nonsymmetrical ambigram, which reads "Death" in one position, and "Life" when it is upside down. "I wanted this design since I saw it in a book when I was fourteen. As soon as I turned eighteen and I could legally get a tattoo, I had it done. It was the first of many."

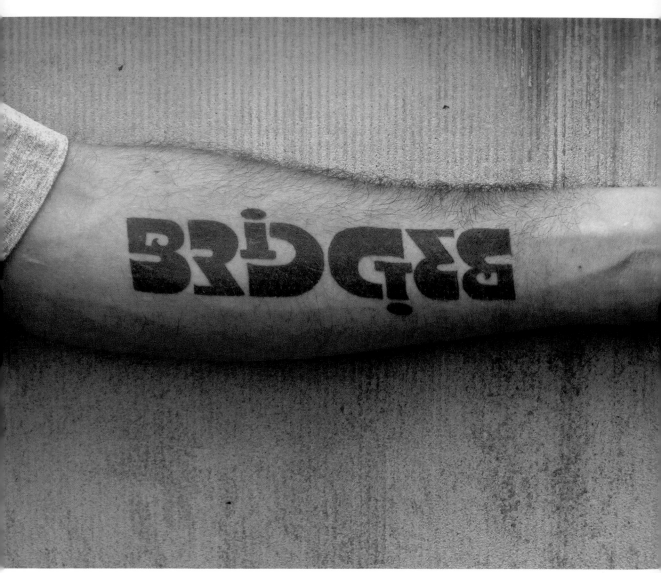

A variety of letterforms can be used to create ambigrams. "I had read *Angels & Demons* and I wanted a tattoo that was unique, so I called John Langdon and to my surprise he was willing to design this ambigram of my last name."

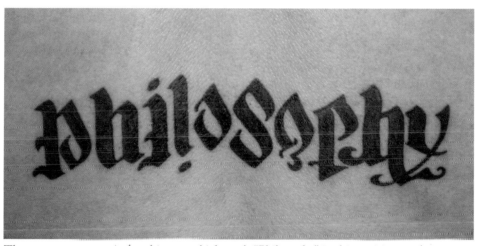

This is a nonsymmetrical ambigram, which reads "Philosophy" in this position, and "Art&Science" when it is upside down.

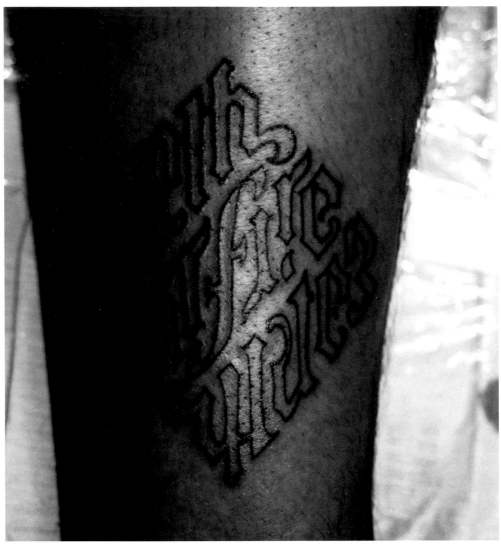

"earth, air, fire, water" is one of John Langdon's most widely copied symmetrical ambigrams.

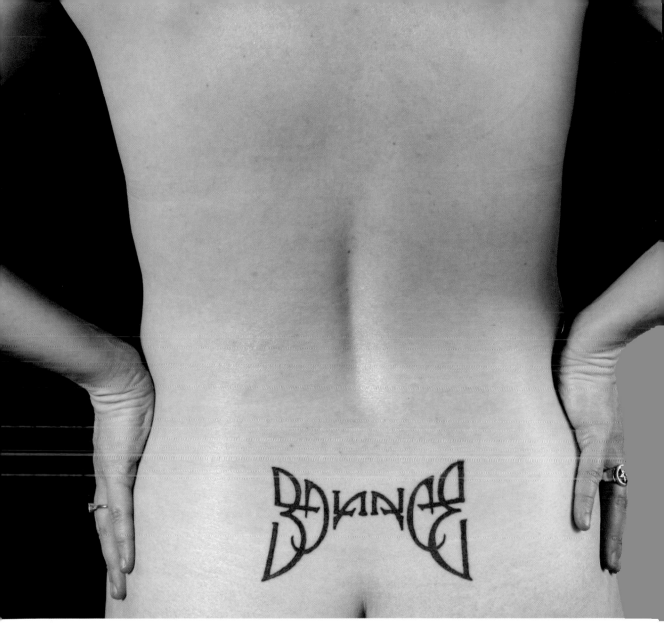

A symmetrical ambigram. "I wanted a conscious reminder of the importance of achieving 'balance' in my life. I strive to consciously and subconsciously align my thoughts and activities with who I am and what I want to do, ideally without conflict or guilt."

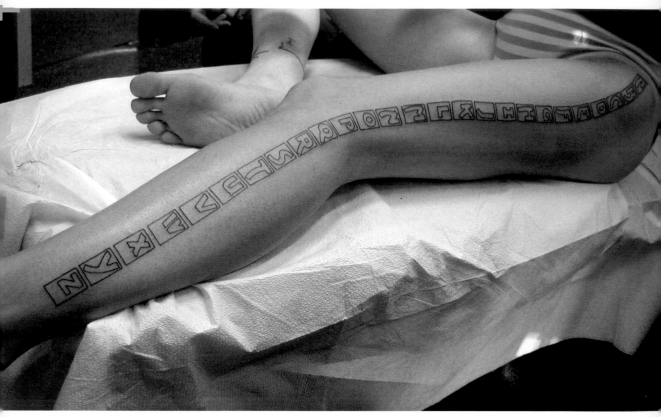

This entire alphabet was tattooed in an art nouveau–style letter design.

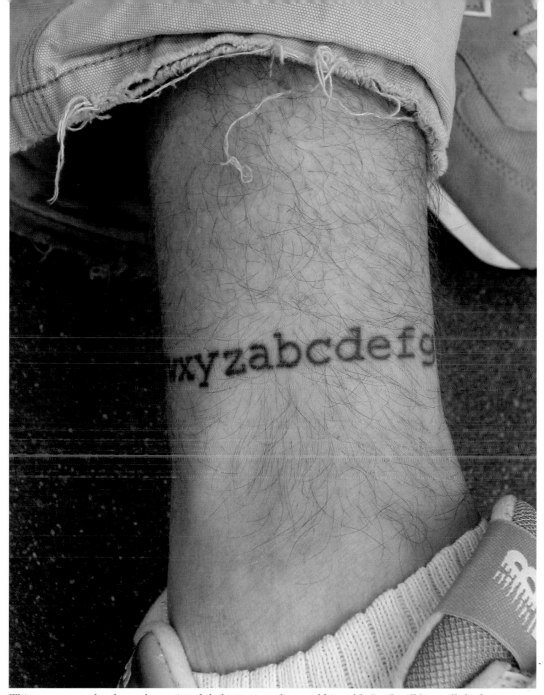

This poet wanted to have the entire alphabet tattooed around his ankle "so I will have all the letters I need with me all the time." He chose the typeface Courier.

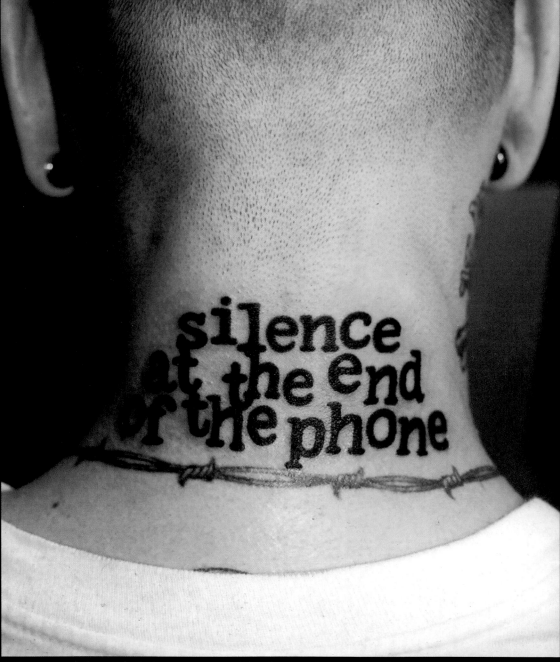

"This tattoo is how I feel about my many friends who died of AIDS."

THREE: SELF-EXPRESSION

EVERY TATTOO REPRESENTS AN EXPRESSION of who we are at our very core. It's a dramatic way to make others aware of our innermost concerns, or to speak out about the thoughts and emotions that define us. Typographic tattoos can articulate intense feelings—feelings important enough to be permanently etched in the skin and made visible to the world. Because these tattoos are words rather than images, they brook little interpretation. They are specific; they offer the precision of language.

Tattoos can be transformative; many are testimony to an inner pain, and can provide a kind of catharsis by their very evidence. Cynicism, hopelessness, and alienation are common themes, yet other tattoos express jubilation and celebration. Some self-expressive tattoos are aspirational; others are marks of a recovery from trauma or a rite of passage. In any case, we need not speak. They speak for us.

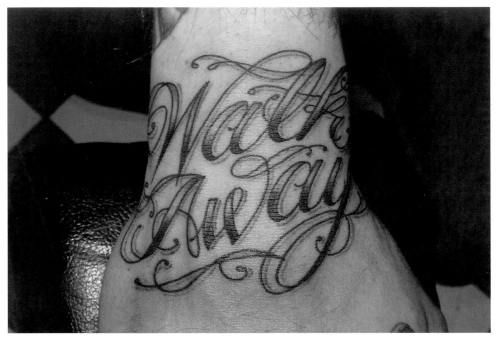

This tattoo is a reminder, for someone who was quick to fight, to change his attitude and remember to "walk away" from the way he used to live. This is a customized flourished script.

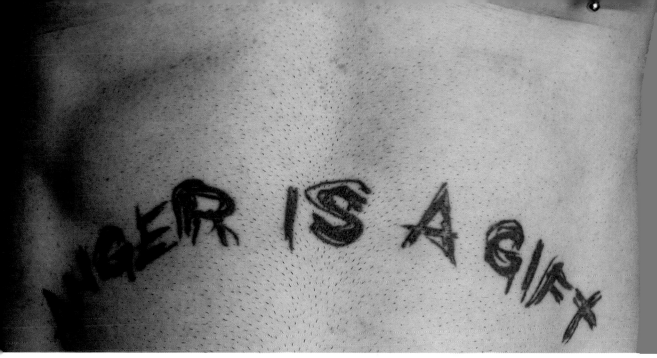

"This is a lyric from the band Rage Against the Machine. It's in a typeface called Grumblefont; I wanted it to look angry, not uniform, out of line; like my life at the time. I used to be pretty aggressive; the tattoo reminds me to this day that I have a short fuse and to be a better person. The disturbing part is that people misinterpret the tattoo. In the Bible, there's a verse about how you can use anger for good."

"I wanted this to look like a ransom note; it was from a time when I was experimenting with drugs and I thought everybody was a cop."

"I like to play with words; this tattoo was a celebration of my degree in English Literature and History. My roommate in college was interested in fonts and had downloaded hundreds of them . . . I combined two typewriter-style fonts to create the design for my tattoo; I changed the sizes around a bit and put it together the exact way and size I wanted."

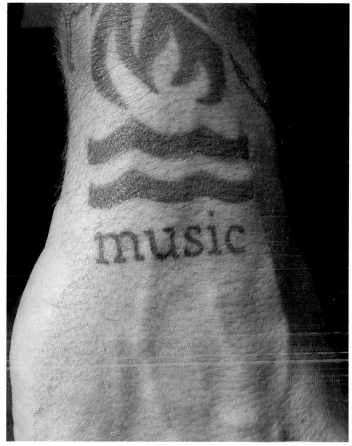

"I got this tattoo because of my deep involvement in music."

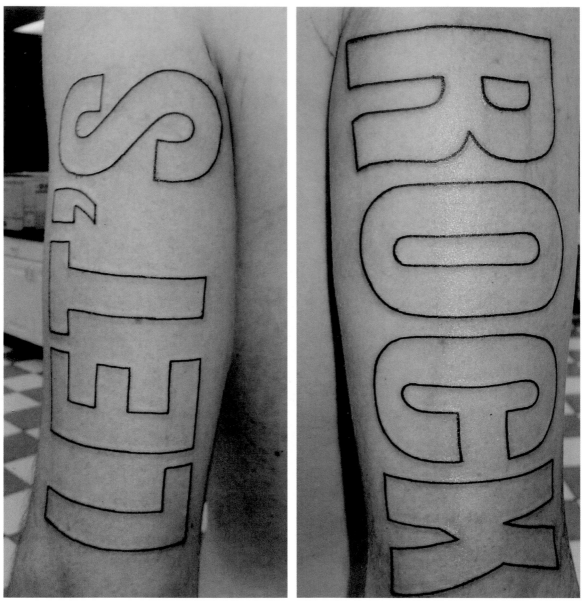

At a concert, with arms raised, the tattoos read as an imperative. The typeface is an outline version of Impact.

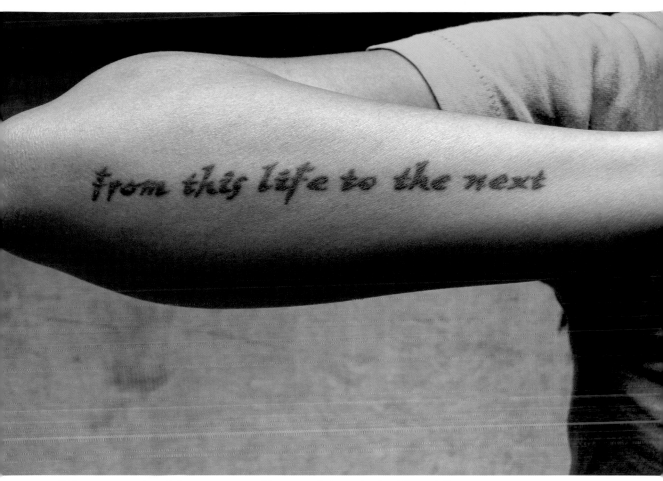

"This is a reminder of the importance of karma . . . I chose the font Visigoth."

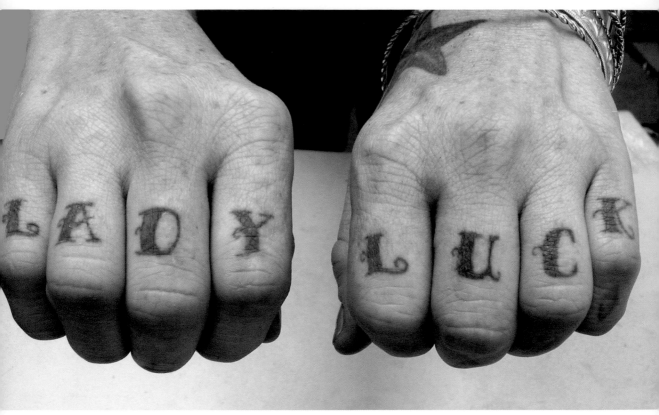

"I thought 'Lady Luck' was cute and feminine. I like being feminine, but I always wanted to be tattooed like the boys."

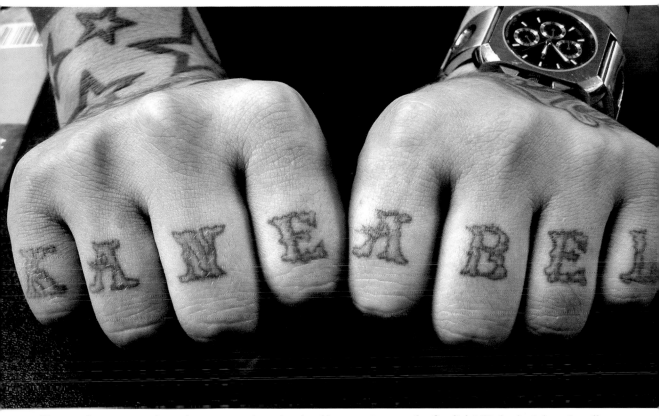

"I wanted to get something that portrayed good and evil but wasn't as much of a cliché. Yeah, that's how I spell 'Cain.'"

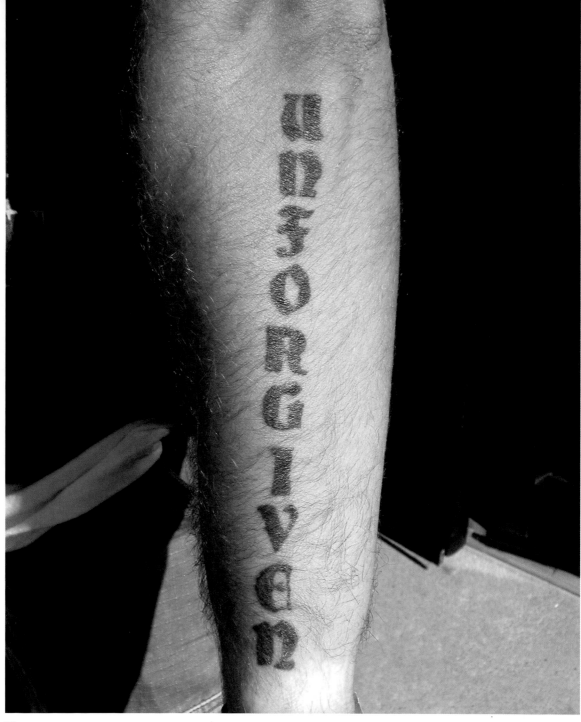

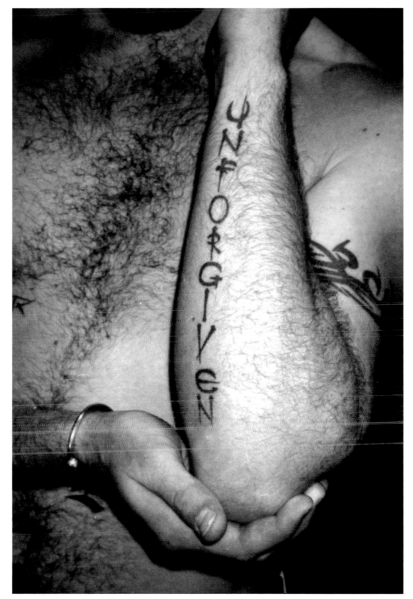

These two tattoos on two separate young men, whom I photographed two years apart, using the same word, in the same location on the arm, stacked vertically, were obtained for the same reason: A declaration to their fathers that they could never forgive them (one said "It was a Father's Day present"). Left: hybrid blackletter/Lombardic letterforms. Right: "Some letters I saw in a book. I liked the futuristic effect."

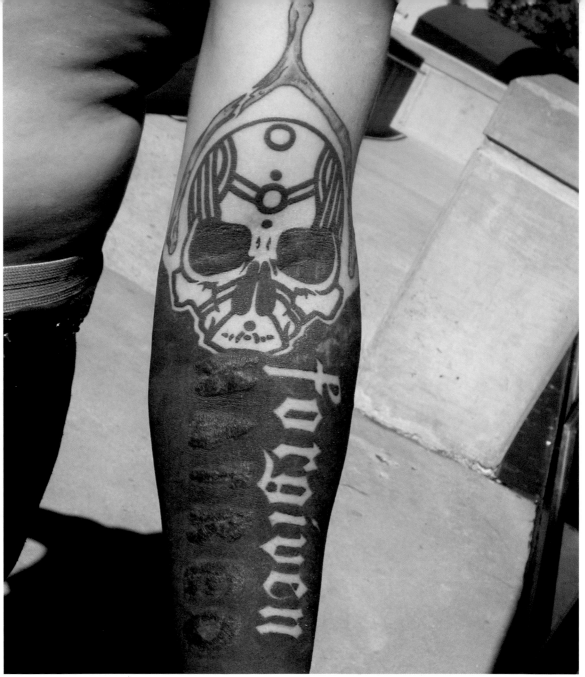

"When I was sixteen, my mother killed herself, so I got the word 'hatred' burned on my arm because she left me alone and I hated her. A few years later I forgave her, and I had the word 'hatred' covered with the tattooed sleeve, replaced with the word 'forgiven' dropped out of the sleeve."

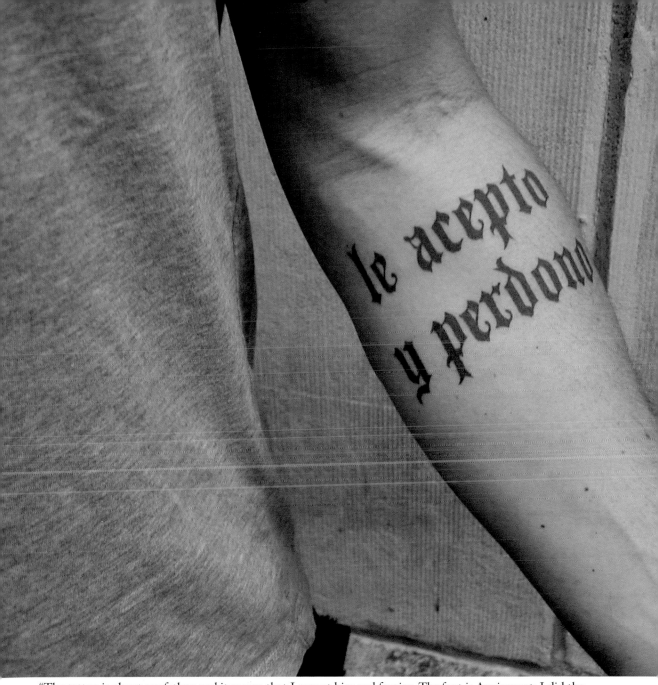

"The tattoo is about my father, and it means that I accept him and forgive. The font is Angiecourt; I did the sizing and spacing on my computer and brought it to the artist."

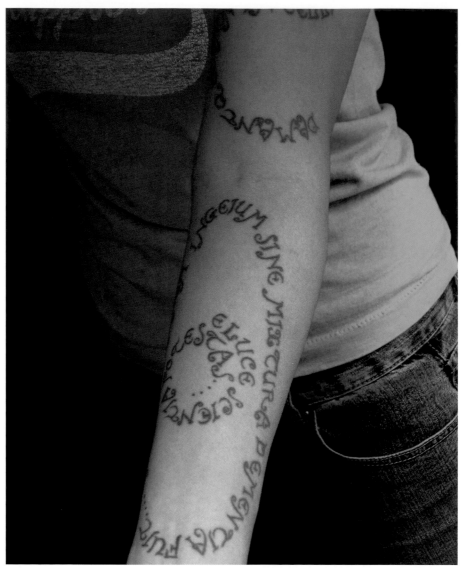

"The tattoos are actually four different pieces of text, all in Latin. The long one means 'There is no great genius without a touch of madness'; the short one on the inside means 'Through the light of knowledge comes power'; the upper arm, 'They condemn what they do not understand'; and, around the elbow (not pictured) 'That which feeds me destroys me.' I wanted the style of the type to represent the past and have a scholarly feel."

"This seemed in keeping with some things that were going on in my life at the time . . . I don't want to be more specific than that." Elaborate flourishing is added around the swashes of the letters, and the vertical strokes are elegantly shaded and highlighted.

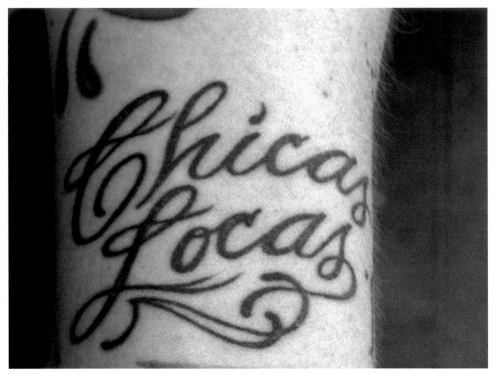

"My girlfriends and I all have the same tattoo ('crazy girls')." This is a hand-lettered script with flourishes; the dot over the i is shaped like a teardrop, reflecting the shapes of the flourishes.

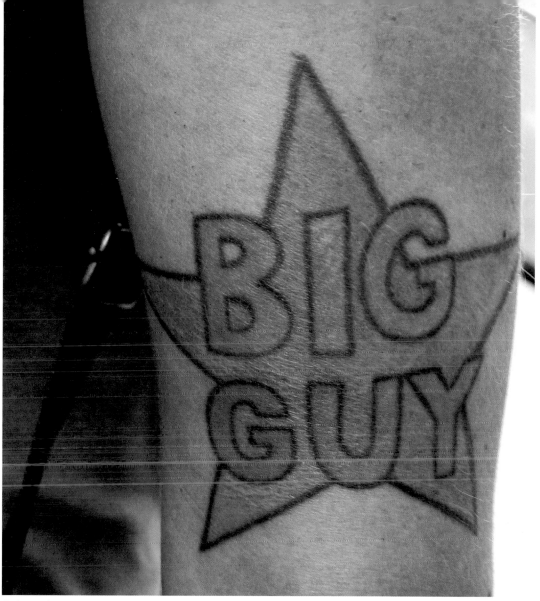

"This is for my memories of ex-boyfriends . . . and hopefully future boyfriends." The chunky sans serif outline caps suggest masculinity.

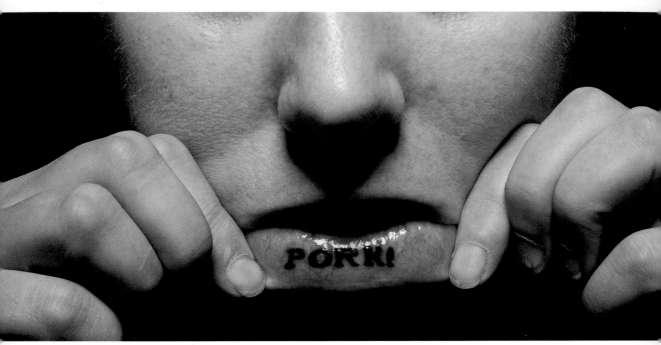

The tattoo relates to working as a cook in the restaurant industry; this appeared in *The New York Times Magazine* in a story about chefs who have tattoos related to their profession.

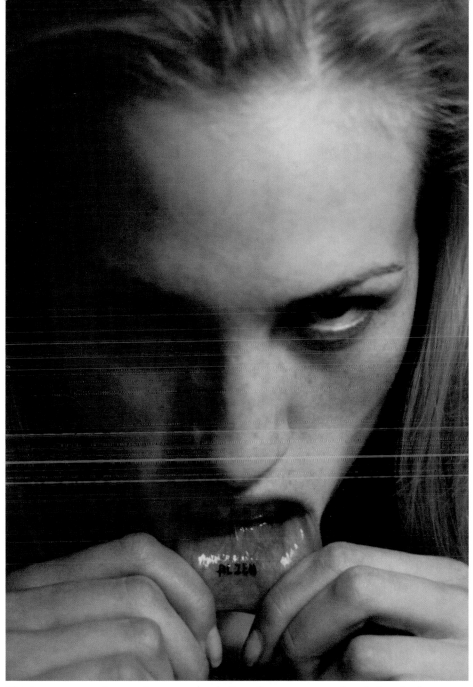

"It's in an unseen place, and represents a feeling of separateness, of not belonging."

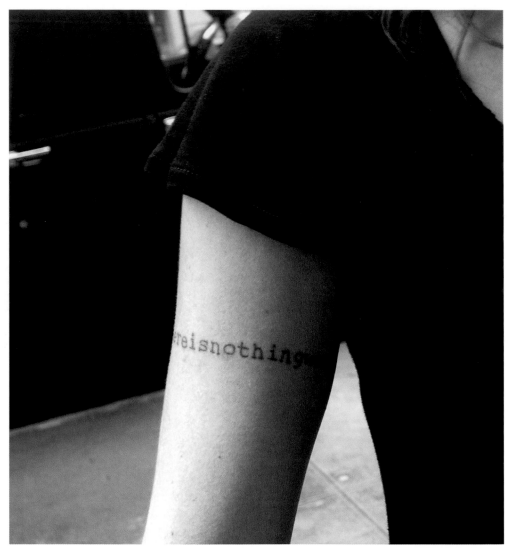

"I have a masters in fine art . . . I'm also in a band and I write songs. This tattoo is a lyric in a song I wrote ('there is nothing worse than insignificant words') about being verbally abused by my stepfather. It was pretty much a spontaneous decision; I took about one day to think about it. I wanted the tattoo in Courier."

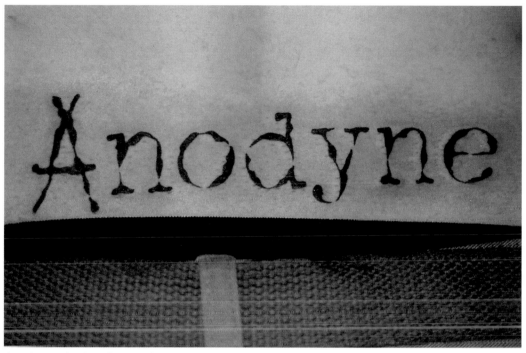

Anodyne: a healer of pain. The typeface is a manually grunged-up typewriter font.

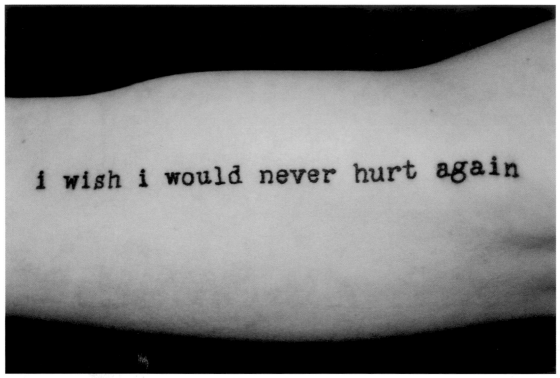

This tattoo was chosen as a talisman to stop the pain. The typeface is American Typewriter.

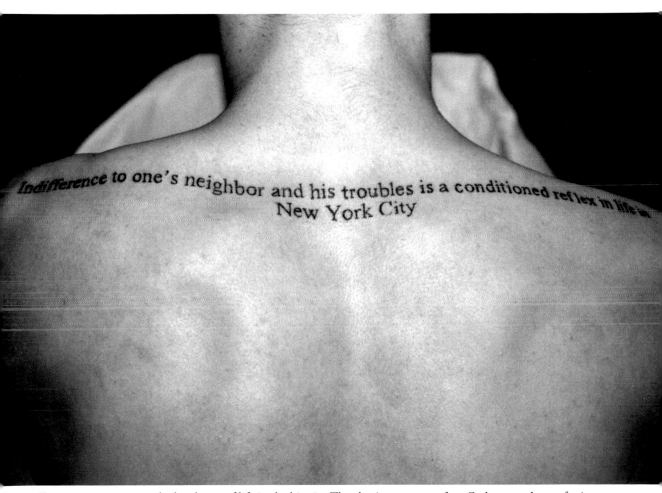

Bitter commentary on the harshness of life in the big city. The classic roman typeface Caslon was chosen for its journalistic feel.

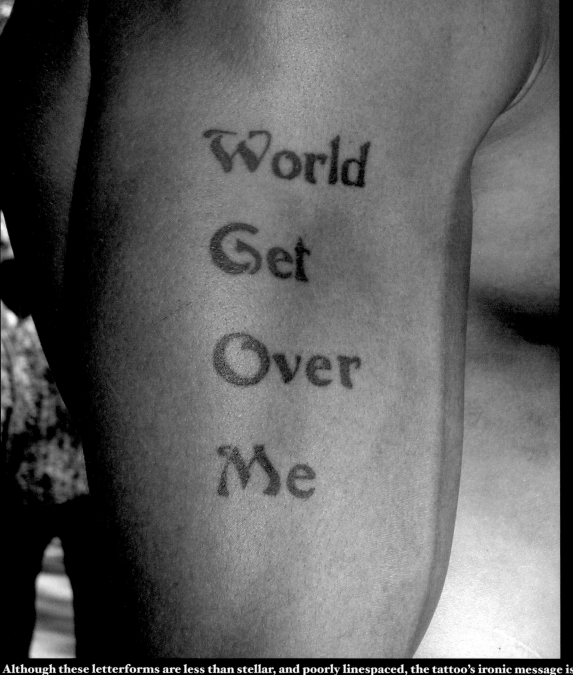

Although these letterforms are less than stellar, and poorly linespaced, the tattoo's ironic message is perfect for this well-muscled hunk strolling shirtless in New York City's Central Park.

FOUR:
SELF-LOVE

A CELEBRATION OF SELF...what better motivation to indelibly mark one's flesh? Narcissism is a common theme in typographic tattoos. Rather than using imagery to flaunt the uniqueness of our identities, why not simply use our own names, nicknames, or initials? Our birth dates, our birthplaces, ourselves...what could be more worthy of worship?

A surprising number of individuals had no more lofty goal than self-aggrandizement when choosing to tattoo themselves. Should this be considered a trivial motivation? In an age when we are endlessly examined by external measures and statistically classified into demographic segments of supposedly like-minded others, perhaps it is to be expected that people will choose to proclaim their individuality with a tattoo. It is a celebration of self, a tangible reminder that we are unique beings upon this earth, and that we have the power to define ourselves.

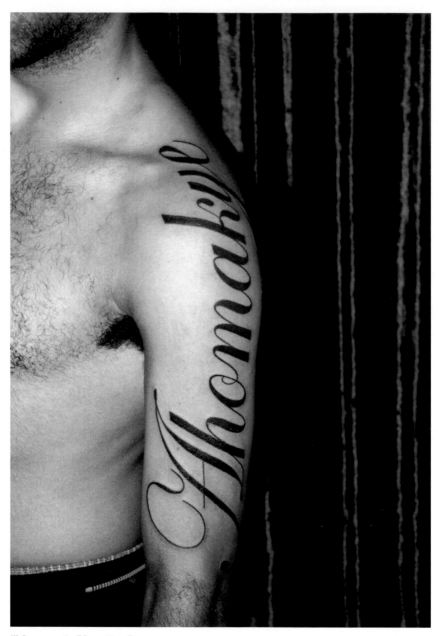

"My name in Hawaiian."

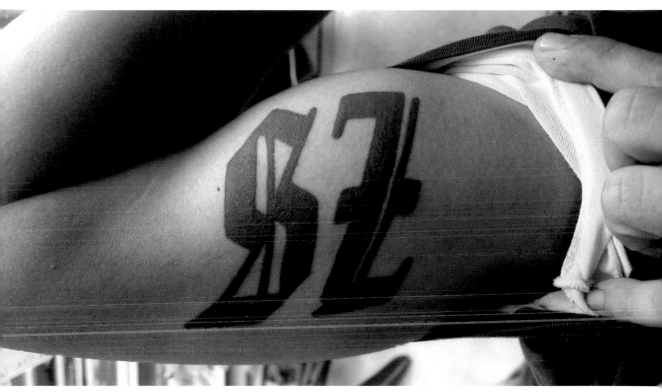

"My initials."

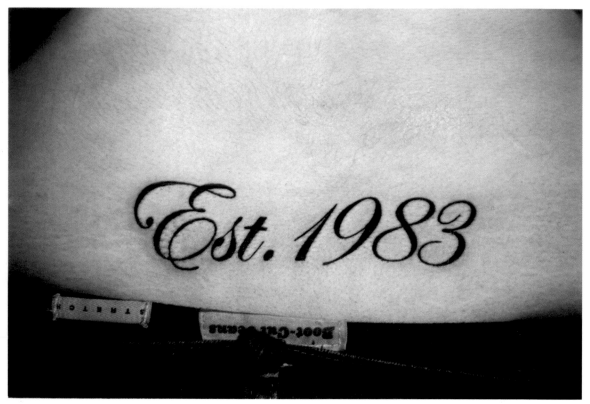

"My date of birth." The design is based on Edwardian Script.

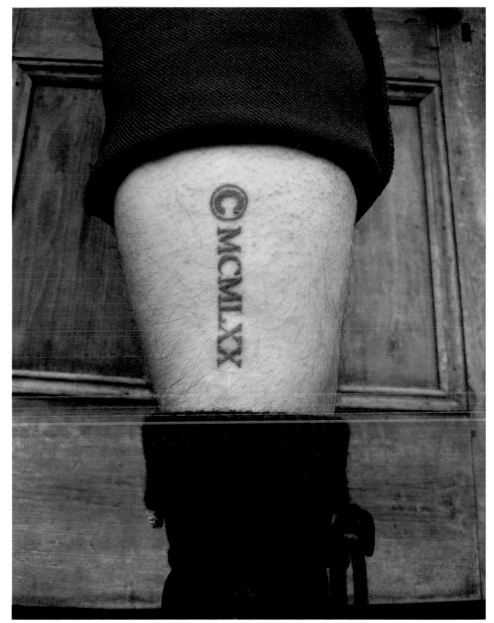

"It's my birth date in Roman numerals. With the world obsessed with cloning, it seemed only sensible to brand the 'original' me. Taking a cue from the Roman numerals used in films, if you are going to date yourself, it could only be done in one typeface: Times Roman. It's a timeless classic, with a suitable gravitas."

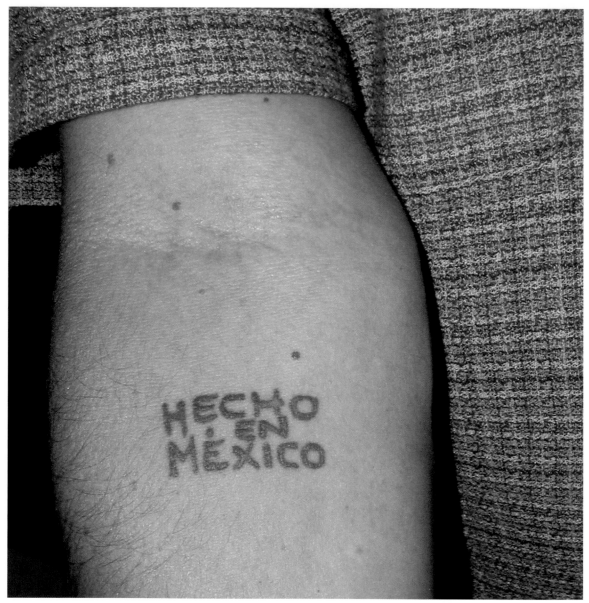

"My parents were living in Mexico when I was conceived." (Translation: Made in Mexico.)

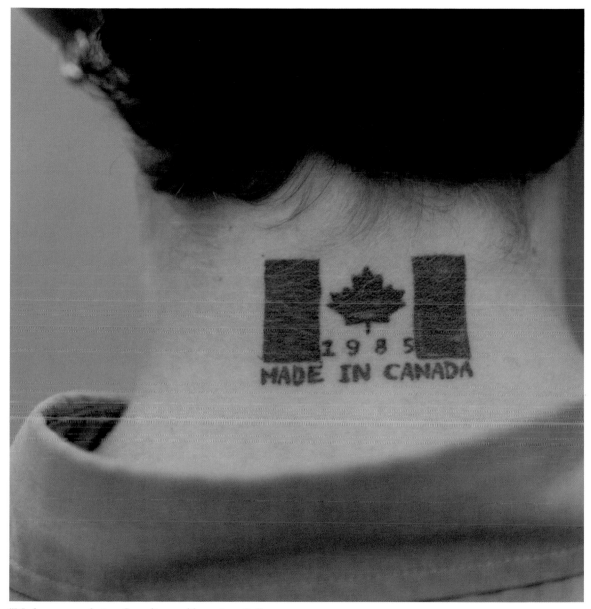

"My homage to being Canadian and born in 1985."

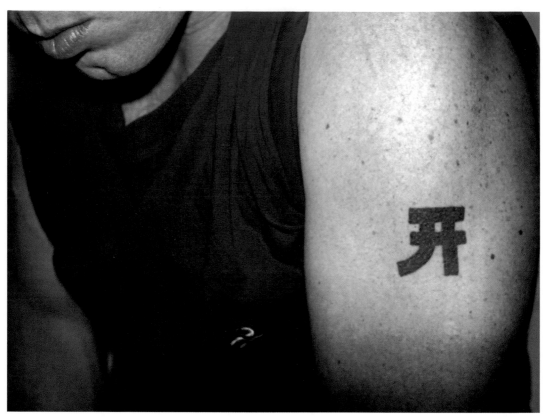

"I am a type designer and art director, so of course I had to design my own tattoo. The A is for my name. I wanted something with oriental traits but still just a letter A; I drew it myself. The meaning is 'open' in simplified Chinese."

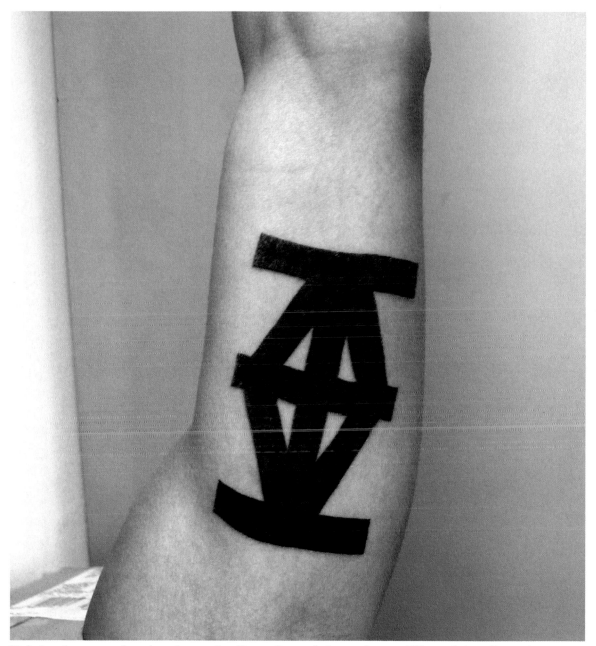

"I designed my tattoo based on the typeface Futura. I am a design student, and I learned about Futura in my typography class last year; I wanted to keep the simplicity and geometry of the typeface. The design is made up of all of the letters in my last name (Ojeda)."

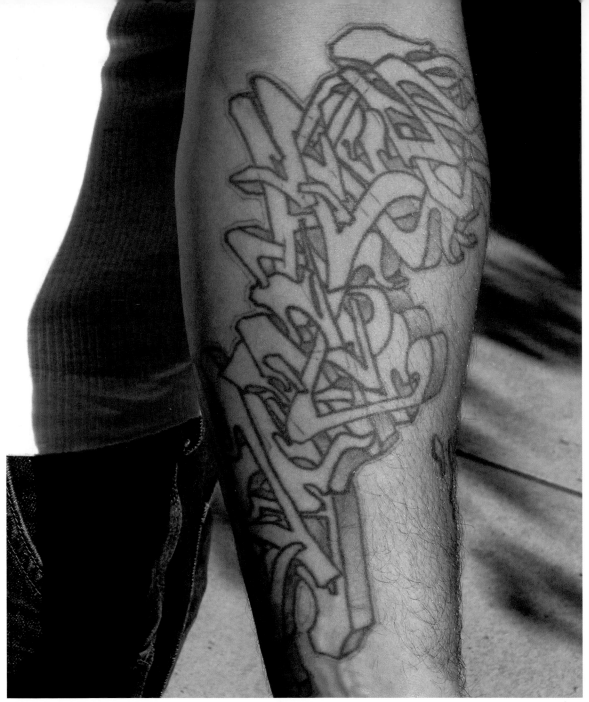

"I am a graffiti artist; this is my tag or nom de plume (Sharp1); it is a re-creation of a painting I did on a wall."

96

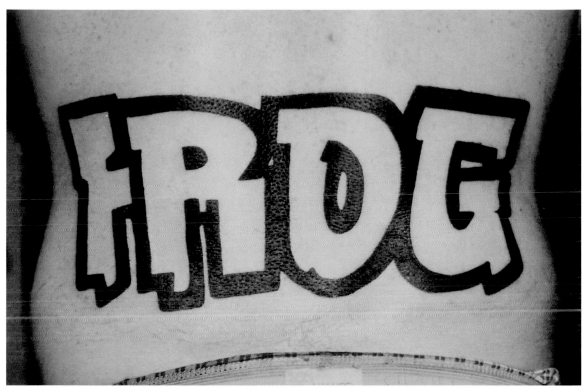

Another graffiti artist with his tag as a tattoo.

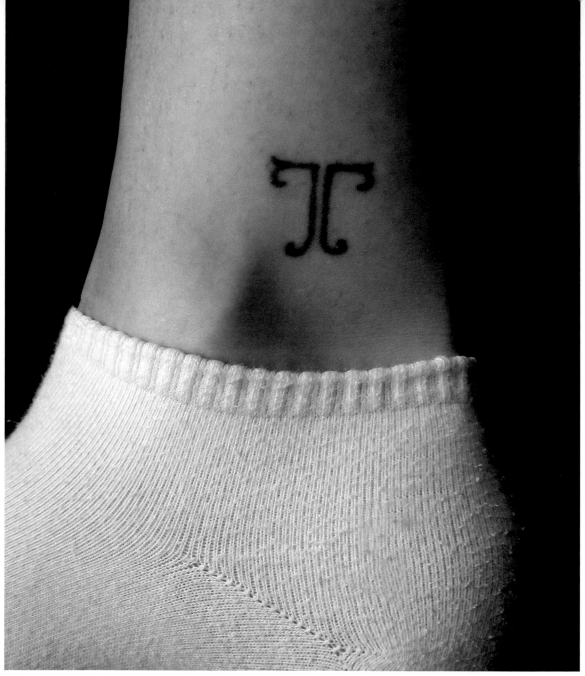

"T is my initial; I had just come back from living in Italy and I wanted something Florentine but not too flourished."

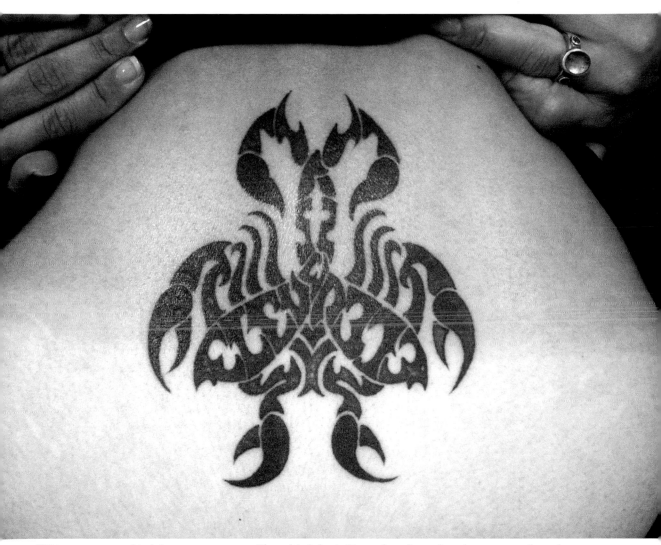

"This tattoo was a birthday present to myself; my birthday is November eleventh and you can see how the designer wove the numbers eleven eleven into my horoscope symbol, Scorpio."

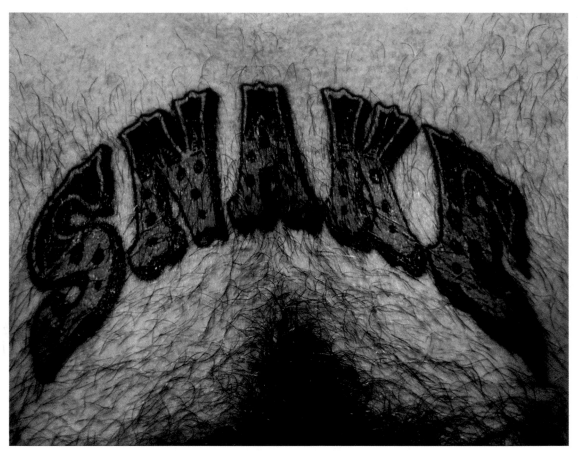

"This is the nickname I have had since I was twelve years old." This traditional form of carnival or circus lettering is a particularly lush and well-articulated version of this letterform.

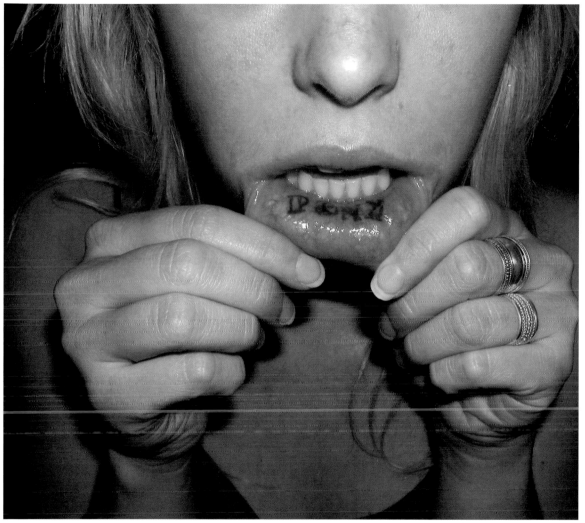

"I'm an opera singer so I couldn't have a tattoo in a compromising place. My nickname is Pony; it is the name of my former band; also my dad is a horse trainer, and inside the lip is where you tattoo horses to ID them."

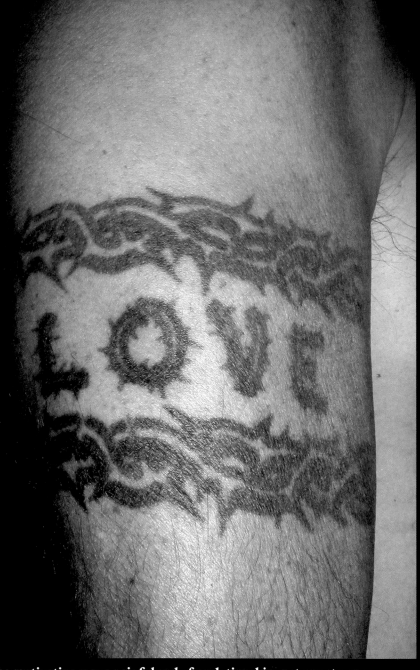

"I designed this tattoo . . . the motivation was a painful end of a relationship; not a nasty one, but painful because the love had been so great."

FIVE: LOVE

AHHHHHH...LOVE. Love in all its forms: love longed for, love lost, love regained, unrequited love, married love, cheating love, forbidden love, painful love, passionate love. Love has inspired every form of expression and demarcation. Perhaps because we know that love can be so transient, we feel the need to make it as permanent as we humanly can . . . in the flesh. Whether to impress the object of our love, or simply to declare our love to the world ("wearing our hearts on our sleeves"), a tattoo embodies commitment in its most literal form.

Tattoos of the names of loved ones are perhaps the most common motivation for a text tattoo, from the stereotypical "Mom" to the memorialization of loved ones who are no longer with us. An entire book could be done on this tattoo theme alone. Grief and loneliness drive many to visit a tattoo parlor for the first time, to mark their devotion to the departed forever in the flesh, to help erase the pain, and to remember.

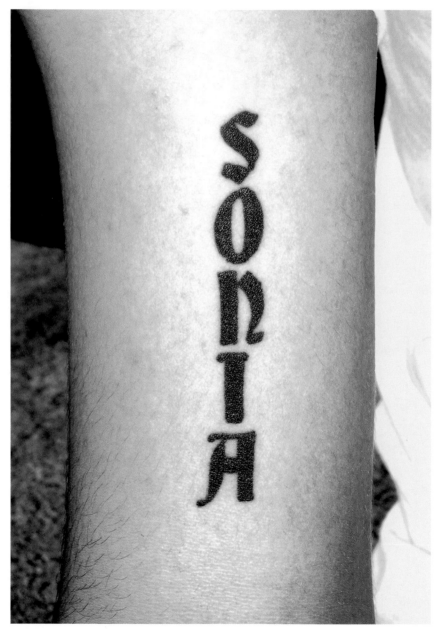

"My girlfriend's name." These Lombardic caps are quite beautiful and a bit quirky.

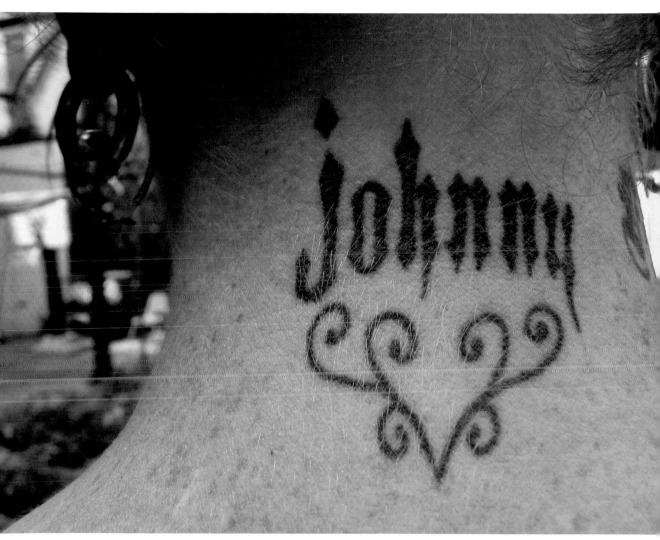

"This is the name of my current fiancé . . . also of my ex." This tattoo is styled in a streamlined, spiky gothic.

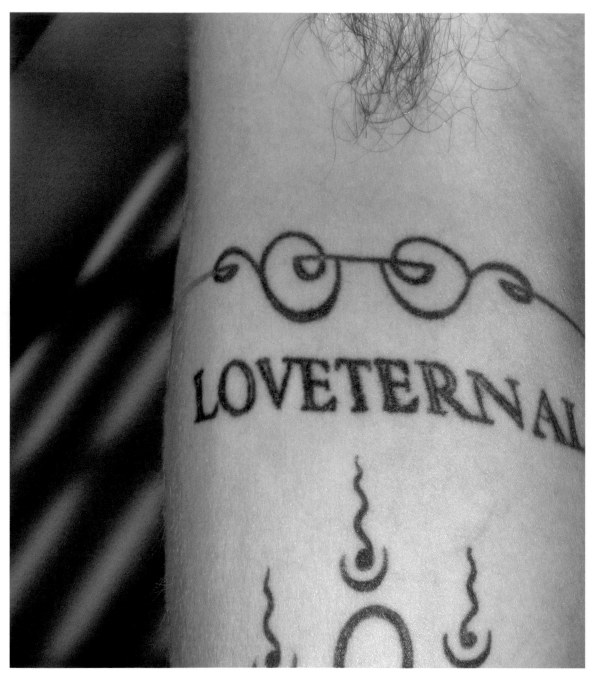

"I got this tattoo for my wife . . . we've been together for ten years; married for six."

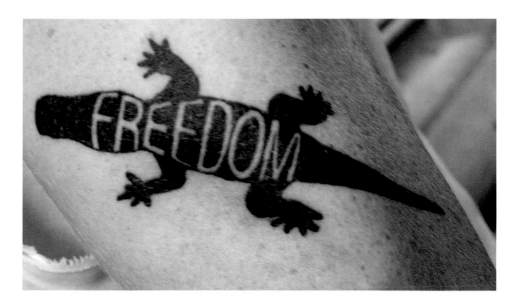

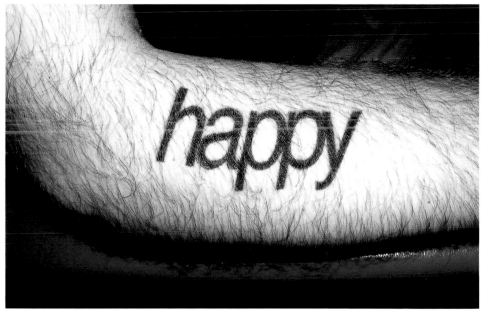

"We wanted to get tattoos to commemorate our love for one another, but we decided to get one another's nicknames because these are words that, no matter what happens, we will be comfortable with for the rest of our lives. 'Happy' is in 120-point Helvetica, my favorite typeface, tightly kerned. 'Freedom' is based on Helvetica . . . I am a graphic designer, and Helvetica is my favorite typeface."

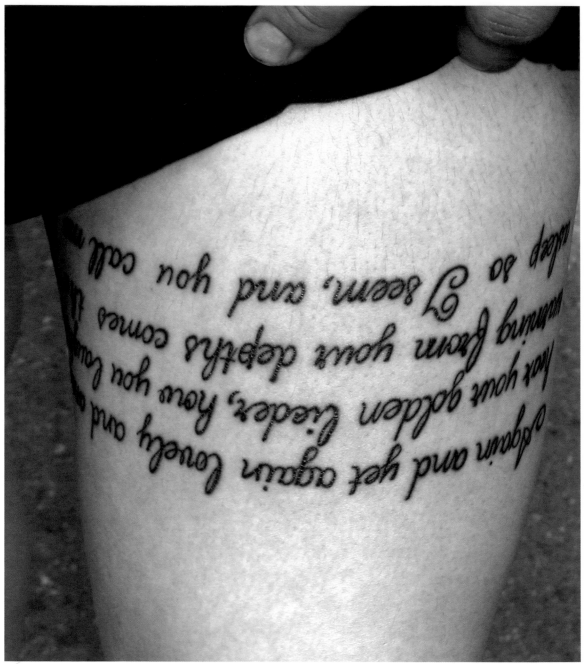

This poem about love is tattooed upside down, so it can be read by the wearer when she looks down at her thigh.

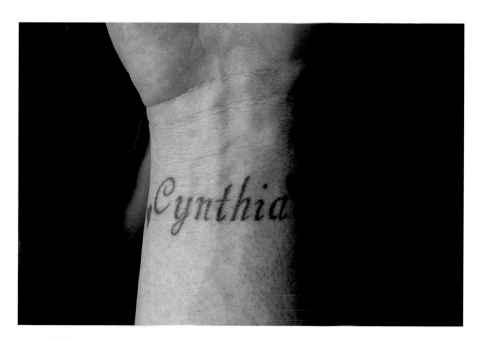

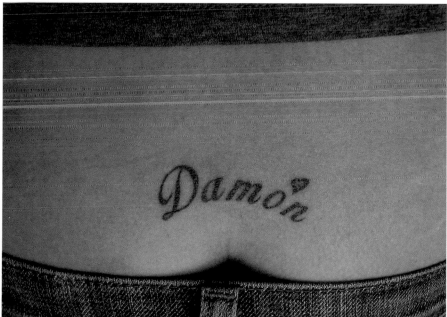

"We got these matching tattoos two weeks before our engagement."

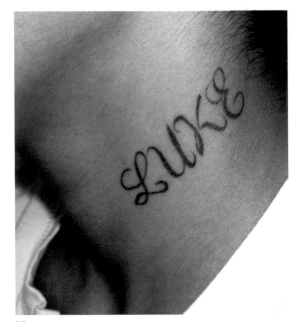

Her son

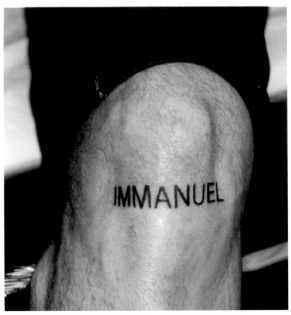

His friend

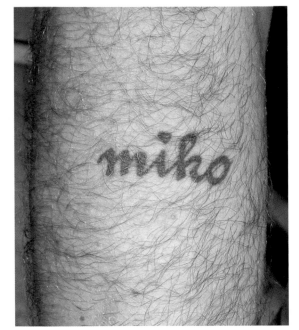

His daughter

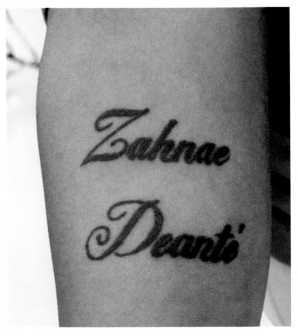

Her children

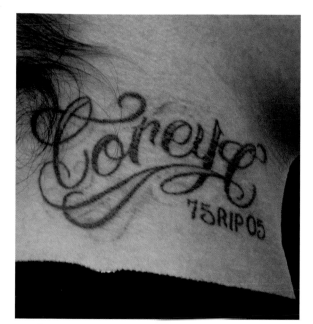

His friend

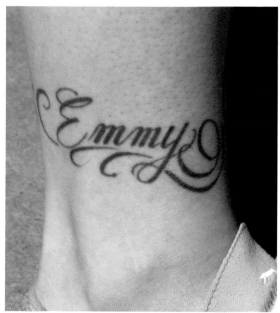

Her daughter

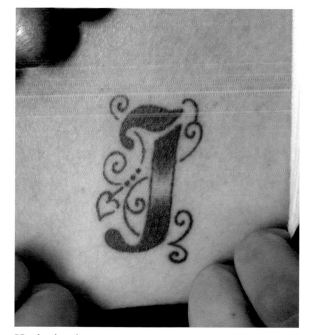

Her husband

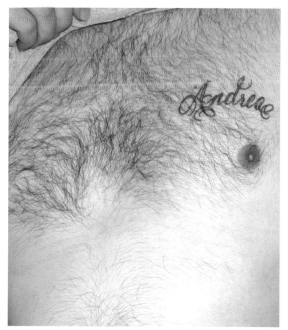

His wife

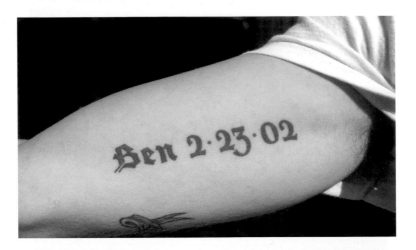

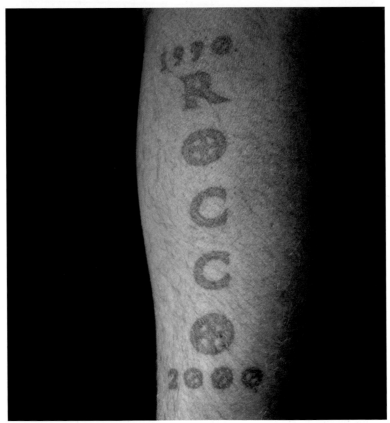

These two tattoos each memorialize the owners' dogs.

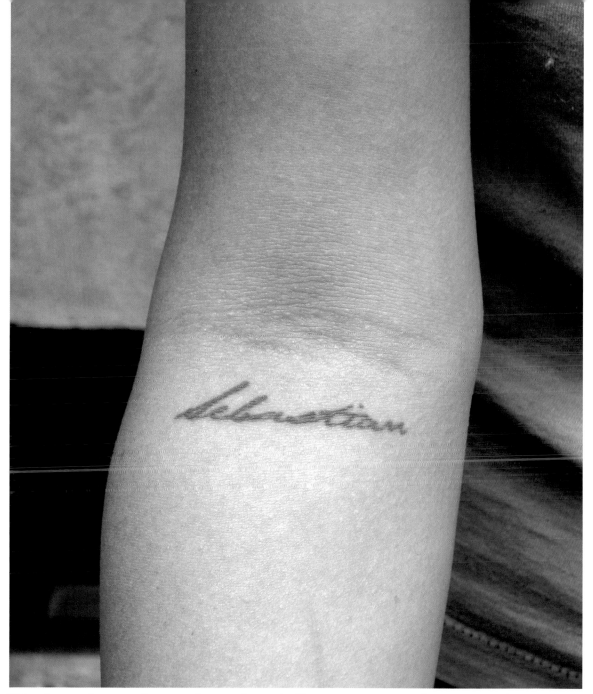

"Sebastian was the name of my cat, who passed away. And by a very strange coincidence, two years later I was given a cat named Sebastian. I chose the typeface; it is Texas Hero."

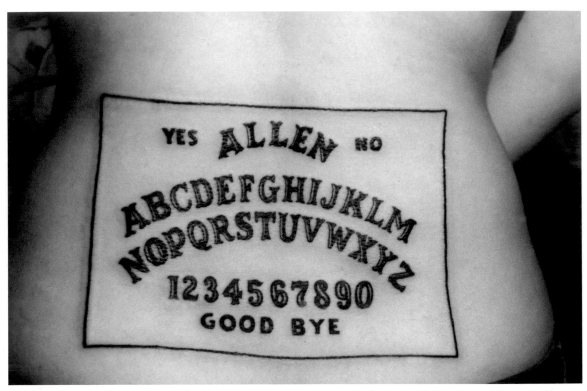

The Ouija Board with the name "Allen" was tattooed to commemorate the name of the contact "discovered" through the use of the board.

"I wanted my blind lover to be able to read his name on my skin, to show my devotion . . . the tattoo spells 'David' in braille. This is my only tattoo, and it allowed me to have a tattoo without having a tattoo."

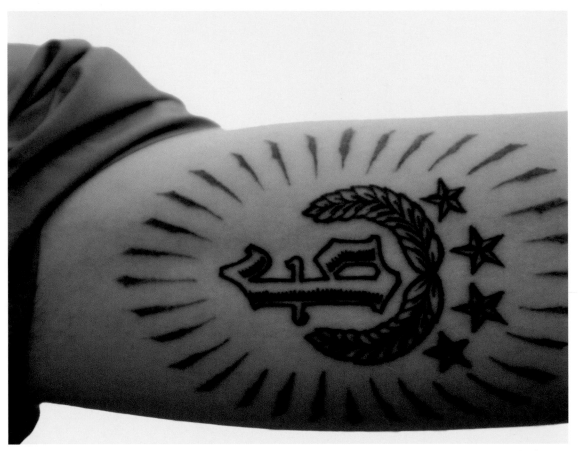

"This tattoo is a family crest that I designed. The letters are roughly based on the font Rapscallion, which is a textured Gothic font. The f and b are representatives of my parents' last names, which I have brought together by making a ligature."

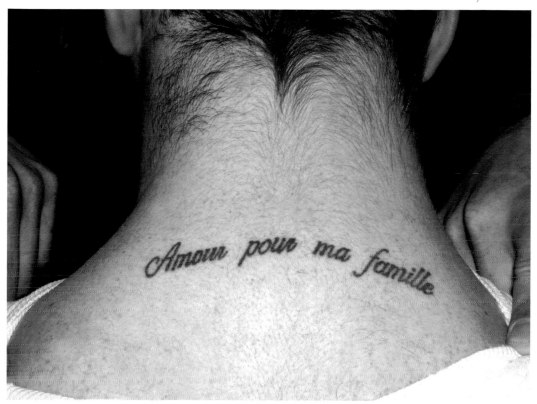

"This means 'Love for my family'... it was my first tattoo, and I figured my family would be inclined to accept it because of the words."

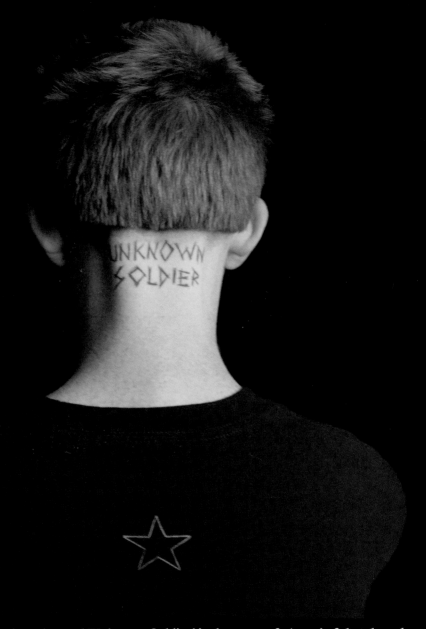

"I am a professional skateboarder, and 'Unknown Soldier' is the name of a 'gang' of skateboarders who are really good but who aren't getting sponsored by the big companies because they don't know the right people. It's about politics in skateboarding . . . it's who you know. I wanted the lettering to be like a kid in the back of the class who is carving into a school desk . . . who keeps raising his hand and never gets called on."

SIX: POLITICS

POLITICAL EXPRESSION AND FREEDOM OF SPEECH are fundamental rights, as is freedom of the press. It follows, then, that tattooing our political beliefs is a fundamental right as well. Protests against the government or the military, proclamations of revolutionary credos, calls to action: These are tattoos in the tradition of great social movements. Words have the power to change the world.

As the saying goes, "All politics is local," and one's own skin is about as local as it gets. We are able to exercise our right to put our personal politics on display, in a way that indelibly proclaims our deep commitment to our cause.

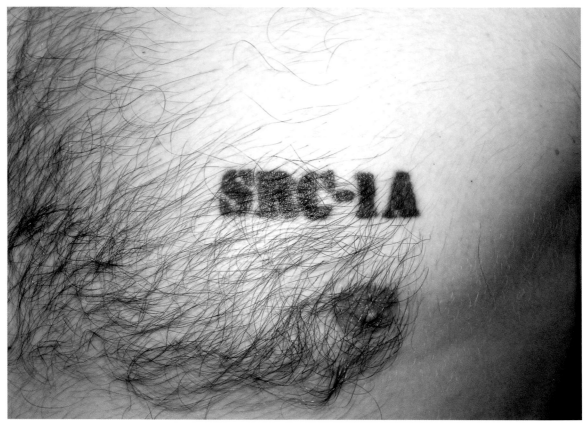

"This stands for 'Subjective Reality Construct 1A' . . . I used the font that the military uses to stencil all its equipment, since I became military equipment by being in the Navy . . . you literally become government property."

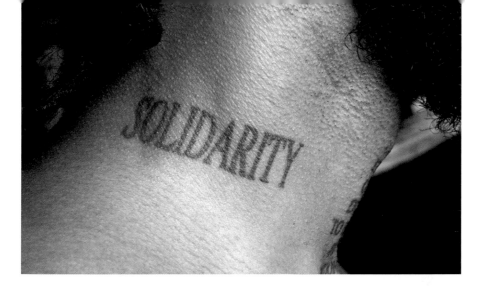

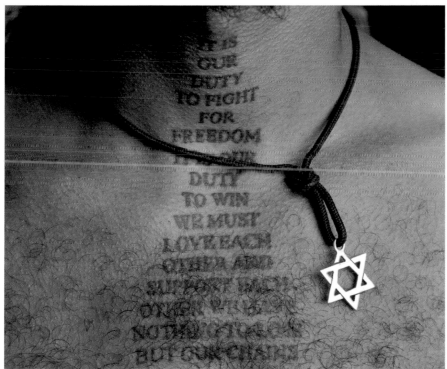

"I got the word 'solidarity' because my friend's sister was killed by soldiers. The neck-piece is a 'revolutionary manifesto.' I have this thing for Times Roman and Times New Roman. I thought a lot about caps versus lowercase. Since the words are the center of everything, I decided on caps."

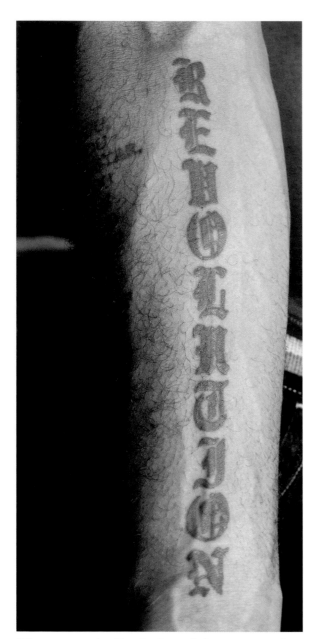
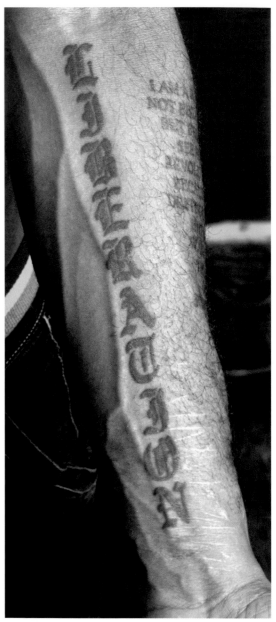

"These are words of inspiration and also a common rhyme pattern when I sing in a dance hall with my band."

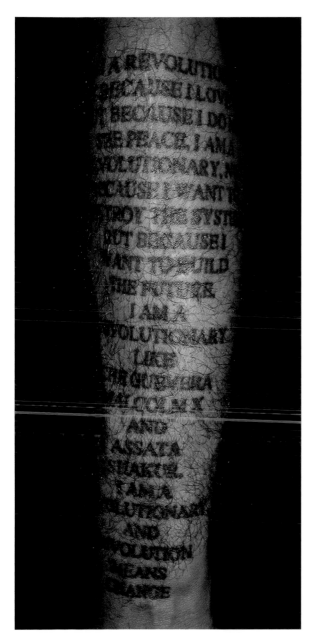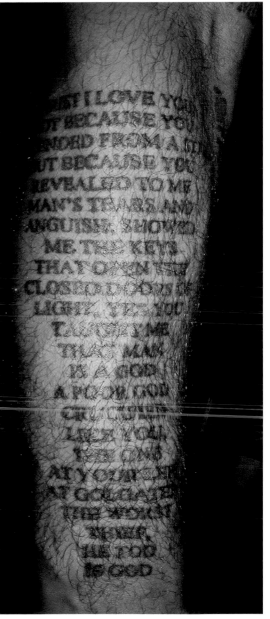

"The text that begins 'I am a revolutionary' is paraphrased from the autobiography of Assata Shakur, Tupac Shakur's aunt . . . she was a leader of the Black Panther party. I added the line about Che. The text that begins 'Christ I love you' is a poem by Felipe Leon that was found in Che Guevara's backpack when he died . . . this poem moved me because Che, who was not known for being religious, was meditating on Christ, and he became a Christlike figure."

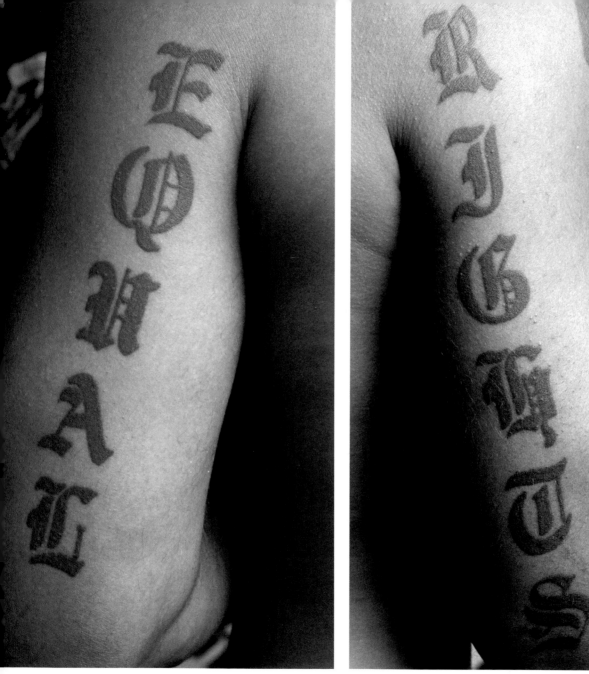

"I was once arrested (falsely) for armed robbery. After that I had these words tattooed onto the backs of my arms . . . if I was ever arrested again, I wanted the police to read the words when they handcuffed me behind my back."

124

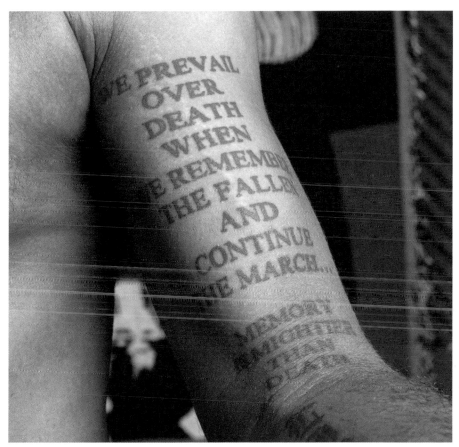

"This text is by Mumia Abu-Jamal, and it is a meditation on his experiences on death row . . . a revolutionary text."

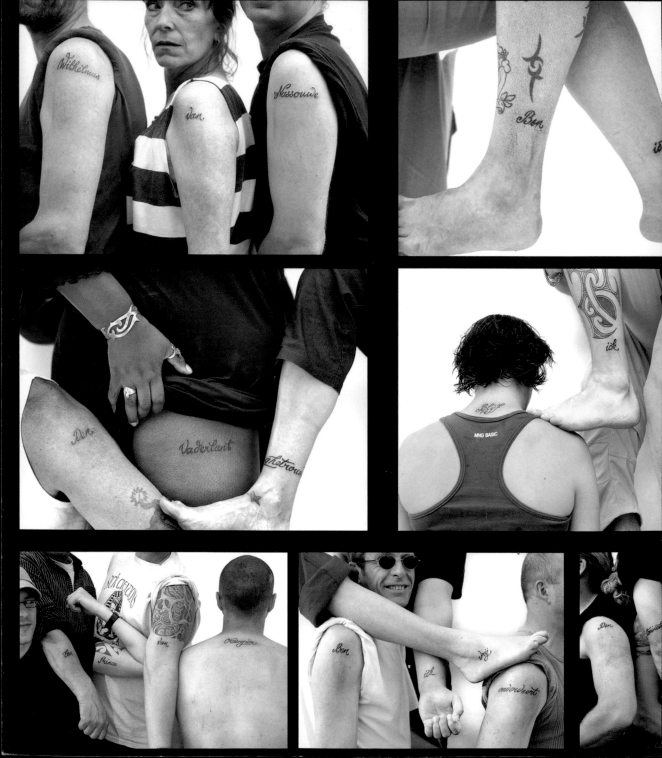

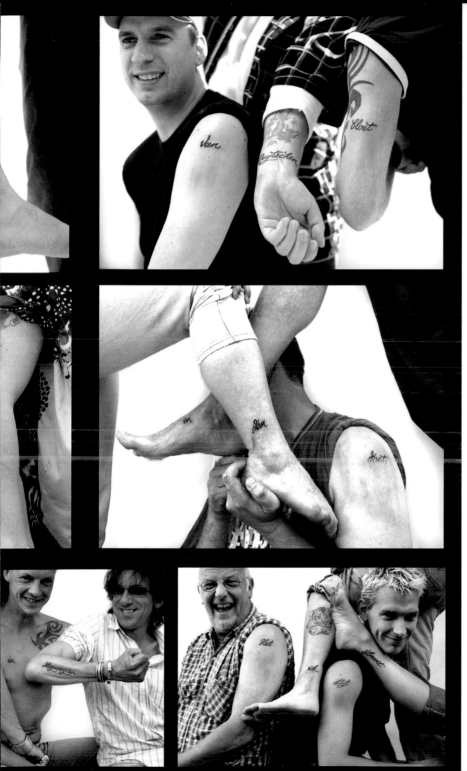

This group tattoo was a protest against the queen of Holland, who wanted the Dutch national anthem, *Wilhelmus*, to be played only in her presence or the presence of a member of the royal family. This disturbed many Dutch citizens, one of whom (the legendary tattoo artist Henk Schiff-macher) decided to "give back" the Dutch national anthem to the people by tattooing 33 men and women with the 33 words of the first verse of the anthem (in ancient Dutch). These citizens, selected by Schiffmacher to represent the diversity of the Dutch populace, thus became "Knights of the *Wilhelmus*," and official bearers of the Dutch national anthem. The protest worked, and the queen relented.

Translation: Wilhelmus van Nassouwe [the queen's forefather]
Am I of German blood
Loyal to the fatherland
I remain until death
The Prince van Oranje
Am I without any fear
The King of Spain
I have always honored.

127

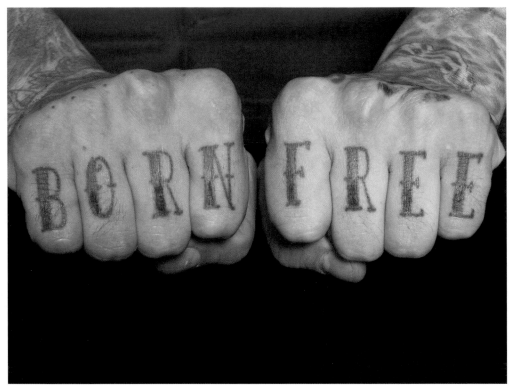

"Society wants to put you into a trap; I got the knuckle tattoos to remind myself that I was 'born free' and I can leave everything behind if I want to. The 'American' tattoo is about pride in being American. We are supposed to have freedoms in America, but when our country was born we had more freedom than we do now."

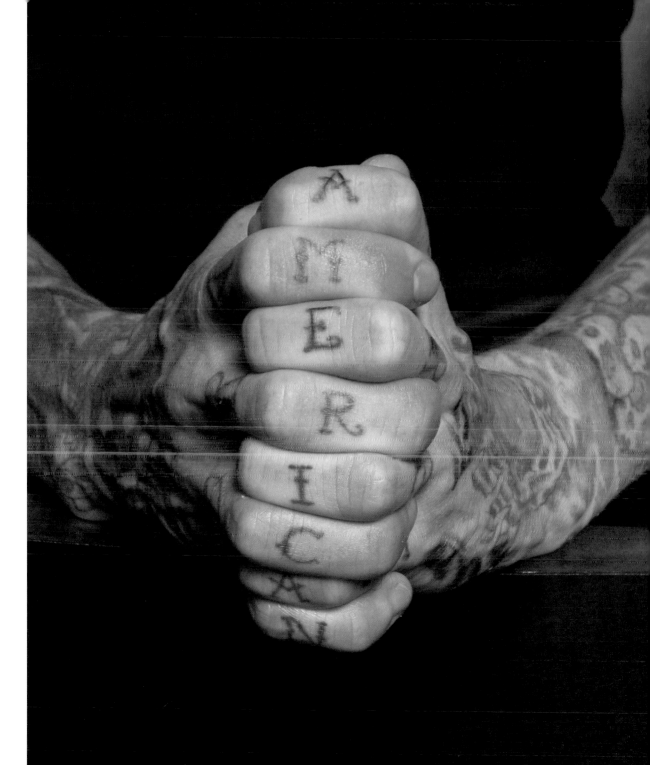

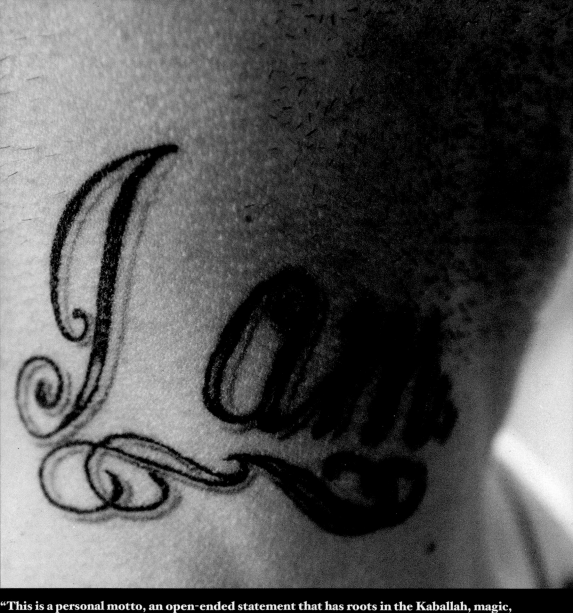

"This is a personal motto, an open-ended statement that has roots in the Kaballah, magic, Wiccan lore, and the Freemasons. And when God spoke to Moses through the burning bush, he said, 'I am who am.'"

SEVEN: RELIGION

ONE OF THE OLDEST MOTIVATIONS for tattooing, and one which continues to be enduringly popular, is a tattoo as a mark of devotion to our faith, including biblical passages, tattoos in the sacred language of the church, and prayers. Although some religions discourage or even forbid tattooing, the pain and suffering associated with the acquisition of a tattoo assuages guilt and dovetails with the notion of resolute adherence to the tenets of our religious beliefs.

The significance of a tattoo's permanence and the symbolism (as well as the reality) of the blood which must be shed in acquiring it appeal to those who hunger to connect more closely with their religion. Believers also seek to ensure the protection of their chosen powerful deity by declaring their loyalty in the flesh.

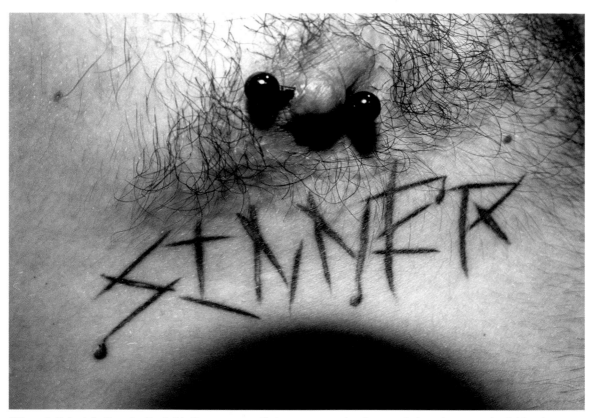

"Though I don't believe in God, I believe we are all sinners, every day. I wanted these letters to look like they were carved into my flesh."

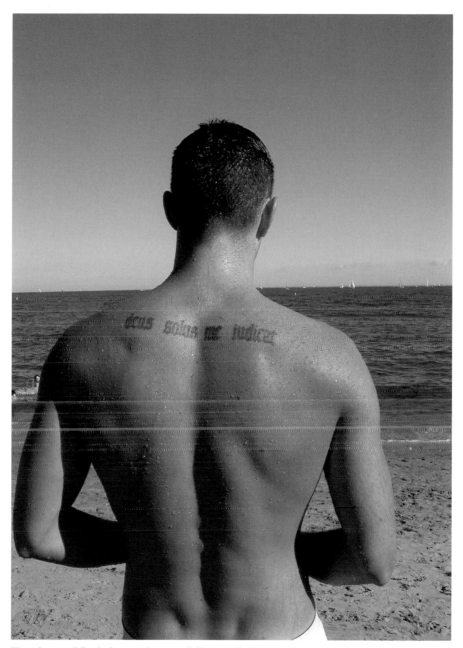

Translation: "God alone judges me." "I was taking Latin at the time, and I wanted to get something that not everyone would understand. It reflects my religious views . . . that it's not about people telling one another what to think."

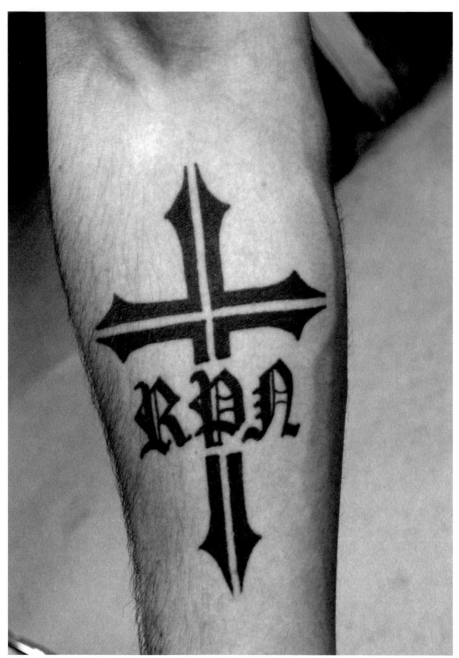

"My brothers and I all have the same tattoo; those are our initials. We are a
religious family."

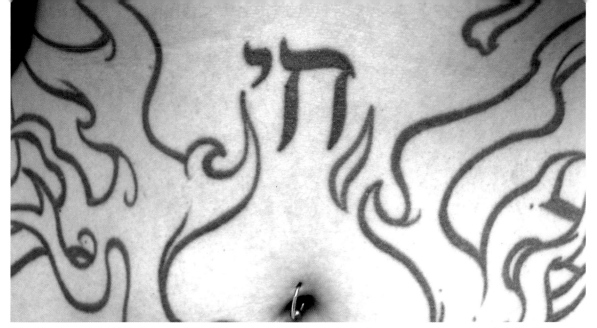

The Hebrew symbol "chai" means "life." "I got it with a friend who had AIDS, to celebrate his birthday. He got his on the back of his neck."

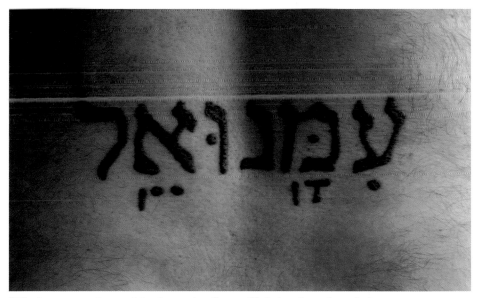

"All of my tattoos have spiritual meaning. I am a Christian. I am also a designer, typographer, and type designer. All of my tattoos have a typographic element to them. I believe Christ to be the Emmanuel (spelled in Hebrew)." Translation: God with us. "I carried a photocopy of the word around with me for a year or two before getting my tattoo."

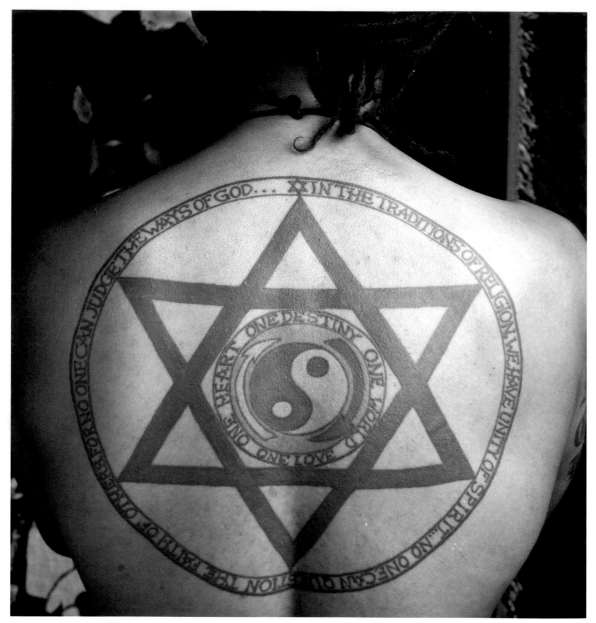

The Rastafarian movement borrows much imagery and ideology from Judaism, thus the star of David. "I had just come back from Jamaica, with the fullness of the twelve tribes. One interpretation of the star is the yin-yang symbol, because you have the potential to ascend. The text is from Haile Selassie; it is my personal spiritual statement, which expresses solidarity with others, and my spiritual awakening."

136

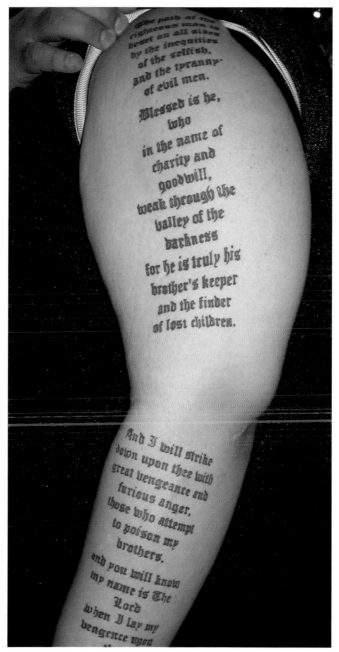

The path of the
righteous man is
beset on all sides
by the iniquities
of the selfish,
and the tyranny
of evil men.

Blessed is he,
who
in the name of
charity and
goodwill,
weak through the
valley of the
darkness
for he is truly his
brother's keeper
and the finder
of lost children.

And I will strike
down upon thee with
great vengeance and
furious anger,
those who attempt
to poison my
brothers.
and you will know
my name is The
Lord
when I lay my
vengence upon

"This is from the Bible, Ezekiel 25:17. It is also quoted by
Samuel Jackson in the film *Pulp Fiction*."

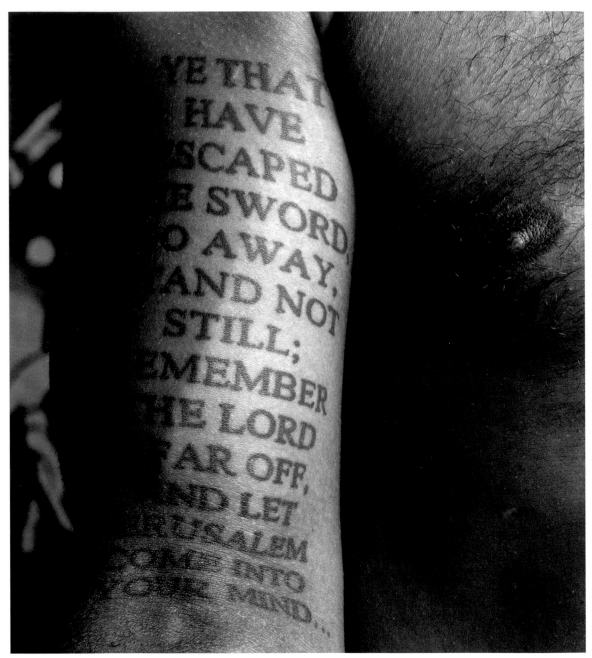

"This is from Jeremiah 51:50. It described my situation; I needed to prove myself, and it confirms my comparison to the prophet Jeremiah."

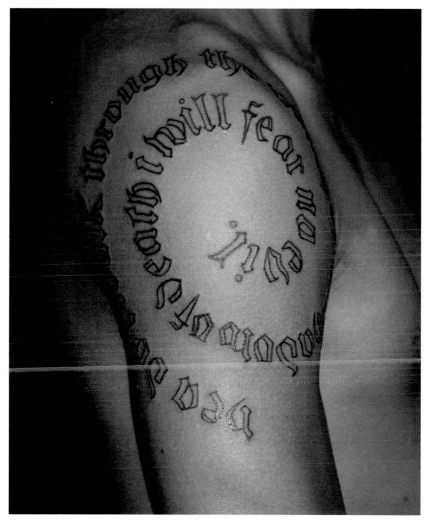

From the twenty-third Psalm, a declaration of God's ability to provide protection from evil.

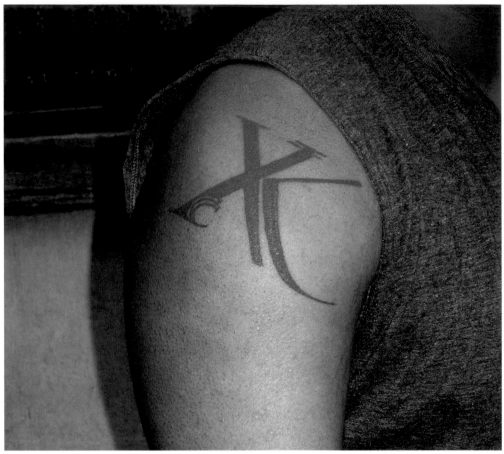

"Eshu or Exu, known as a dark god or demon in the Santeria religion, is a 'trickster figure,' a god of the crossroads who presents you with choices that reveal your true self. In New Orleans we just use 'X.' I designed this tattoo to combine the god's name, my initial, and the initials of my twin brother and my mother. We were at a crossroads and we came out of that."

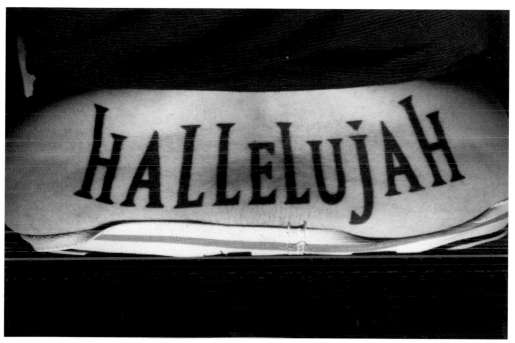

This is the logo for a documentary film about the performer Ron Athey, subtitled *A Story of Deliverance*. The logo is based on the typeface Matrix Tall.

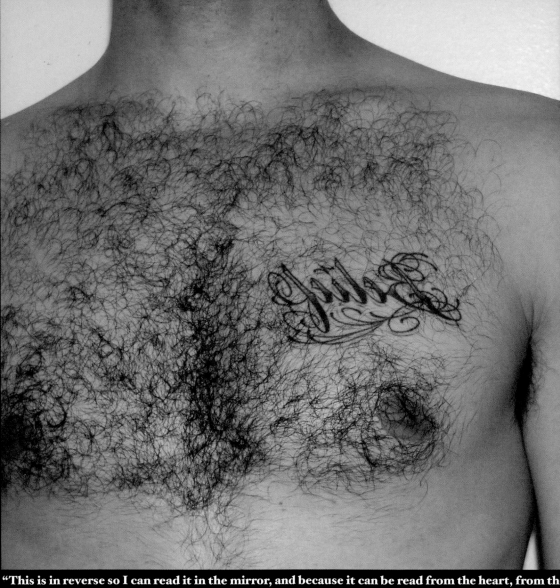

"This is in reverse so I can read it in the mirror, and because it can be read from the heart, from the 'perspective' of the inside. It is a reminder to have belief in myself."

EIGHT:
BELIEF SYSTEMS

WHILE NOT ASSOCIATED WITH a specific religion, many
typographic tattoos spell out deeply held beliefs or convictions,
credos, personal philosophies, and rules to live by. Some text tattoos
are clearly exhortations, reminders to live a pure or meaningful life,
to seek a higher purpose amid the mundane daily grind.

Tattoos that reveal one's personal belief systems are often
intended to uplift one's character and inspire strength, to urge the
wearer to search for truth and justice, and to hold firmly to a specific
way of thinking and being. These text tattoos are generally hopeful
or inspirational in nature, representing the optimistic expectations
that one will indeed live up to the words that have been so carefully
chosen and inscribed.

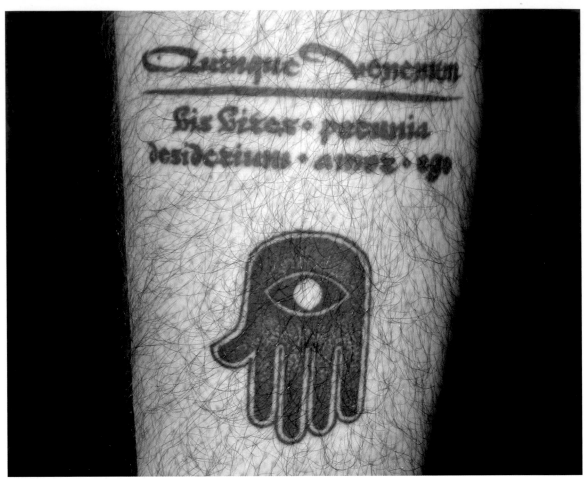

"All of my tattoos are for personal knowledge or strength, beliefs, and thoughts about life and myself. 'Quinque Venenum . . . vis vires, pecunia, desiderium, amor, ego,' which is Latin for 'The Five Venoms: power, money, regret, love, and self.' This is a personal mantra I came up with . . . the goal is to renounce these 'venoms,' not to desire or covet them, which only tends to drive you crazy. I designed this myself (I am a type designer), basing the forms on a civilité from *Fell Types*, a historical specimen book. The Hand of Maat, an Egyptian diety, is a protection 'amulet' from falsity and negative energy."

" 'Carpe Noctum' (I varied this because I am more of a night owl) is a variation on a specimen from *Solo Type*. 'Éclaircissement' ('enlightenment' in French) is something I hope to achieve in my lifetime. The tattoo below means 'be' in binary code, for which I chose the typeface Hoefler Text. Another simple reminder to just be, to be myself. Following that is a Ghanaian symbol representing 'transformation of self.' Then, 'vasthoudendheid,' which means 'perseverance' in Dutch. 'Nitor expletio' is 'to strive for completion' in Latin. These are also based on blackletter forms from *Fell Types*. The Sanskrit quote is a Tibetan prayer mantra which teaches harmony and balance with the environment around you."

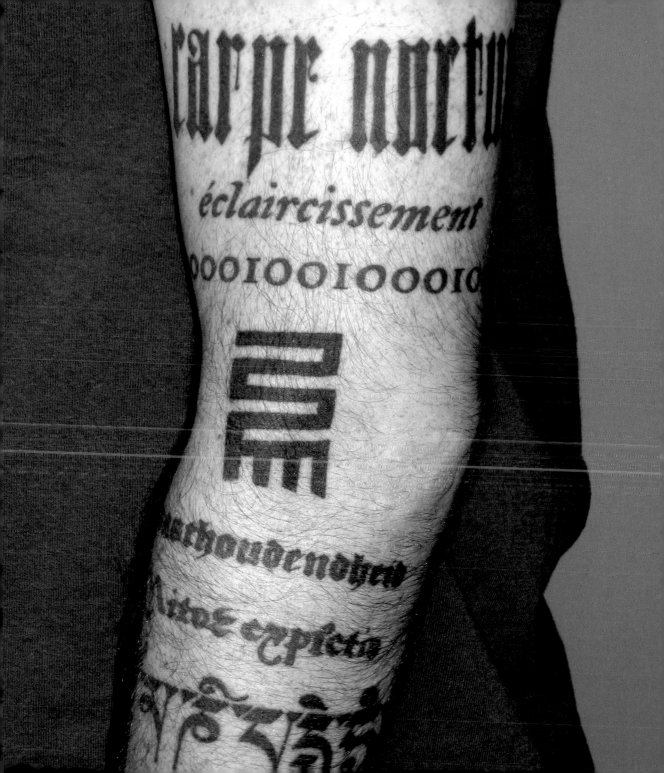

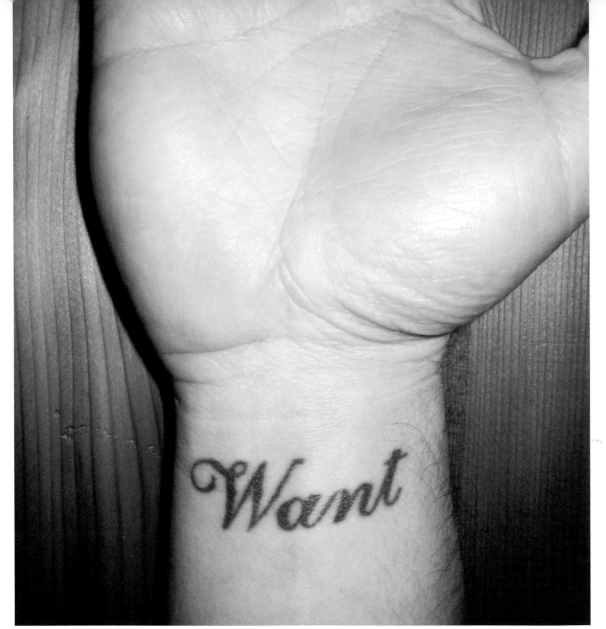

"Many reasons for this tattoo: I was accumulating stuff, buying things unnecessarily, that I didn't need or 'want,' so this tattoo would remind me, when I reached out for something, to question myself, seeing the word 'want' right on my wrist. I was also having a rough time with a girlfriend, not sure where I 'want'ed the relationship to go. Finally, one of my favorite songs is 'Want' by a band called Jawbreaker. I am a graphic designer, and I worked very closely with type designer Jonathan Hoefler to get the tattoo to look just right; it is has been substantially altered but is based on Shelley Allegro BT."

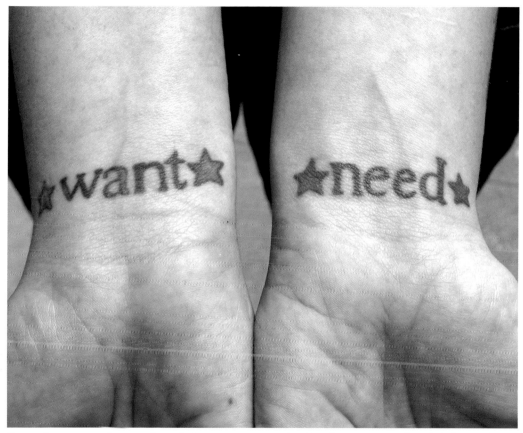

"I got these tattoos because I needed a constant reminder that there was a profound difference between the two. The forms are based on a typeface used in a copy of *Lolita*; ('want' and 'need' are what *Lolita* is about) so I blew up the text from the book for the tattoos."

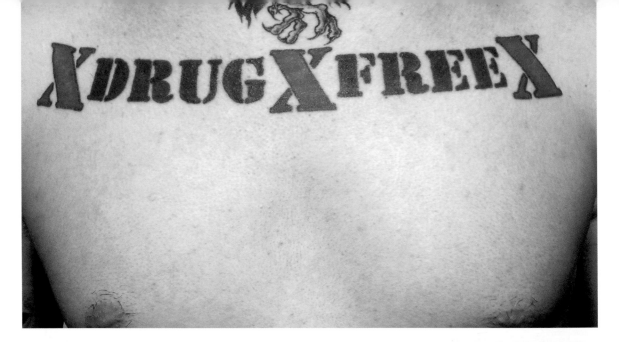

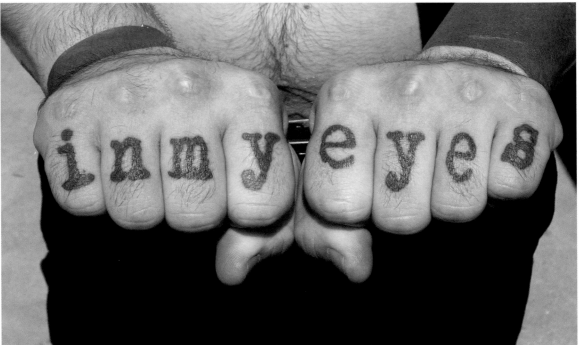

"I got the tattoo 'in my eyes' because it is a song by the band Minor Threat; their song is about why they don't do drugs; it relates to my 'drug free' tattoo, which is a daily reminder for me."

148

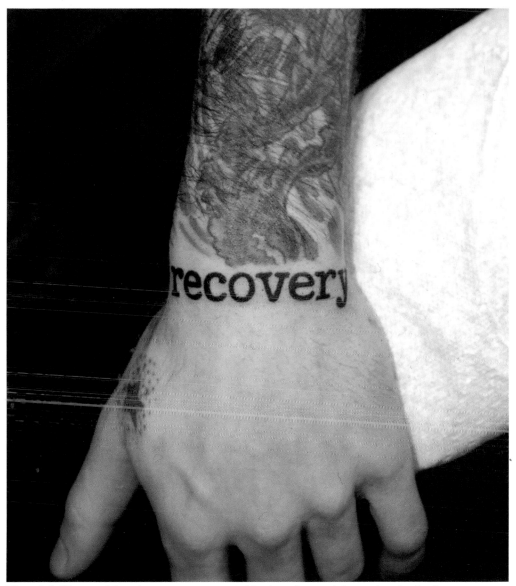

The triple-X or straight-edge movement started in the 1980s, and those who obtain these tattoos want to have a visible commitment to stay "clean." Triple X refers to no drugs, no alcohol, and no promiscuous sex. The tattoos on these pages and the following four pages all share this theme.

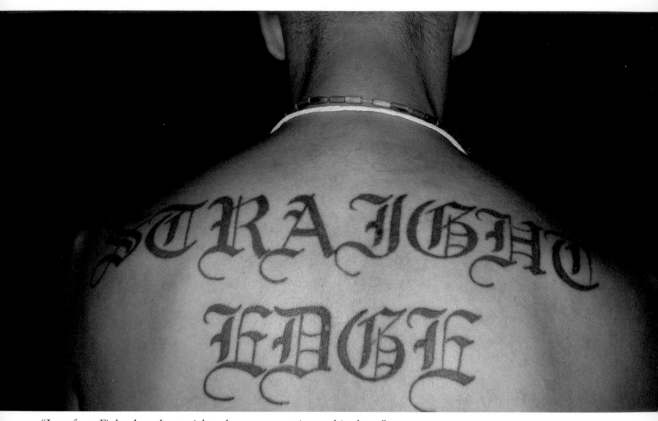

"I am from Finland . . . the straight-edge movement is very big there."

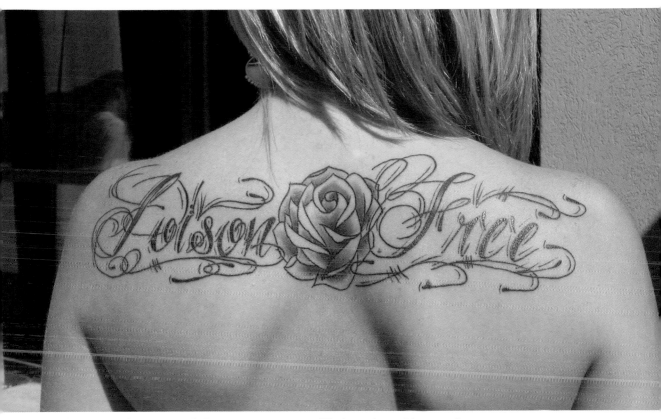

"My 'Poison Free' tattoo stands for my recovery . . . my life depends on this tattoo."

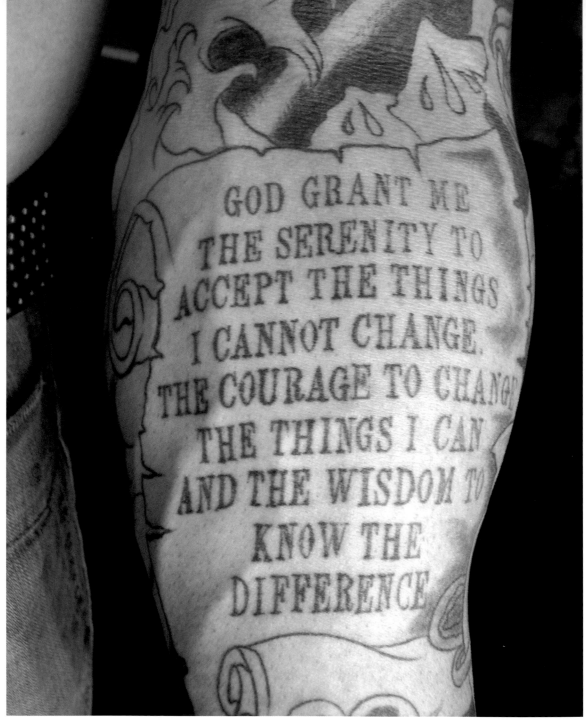

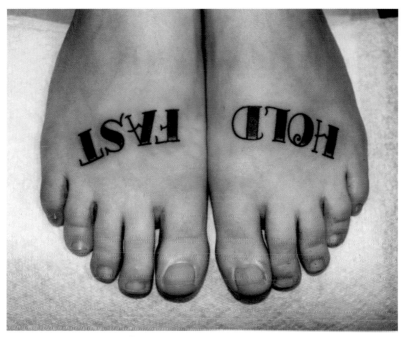

Opposite: The Serenity Prayer is closely associated with the twelve-step recovery program. Above: Another phrase to commemorate the commitment to stay "straight."

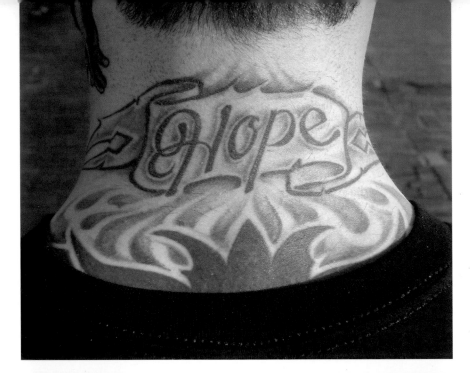

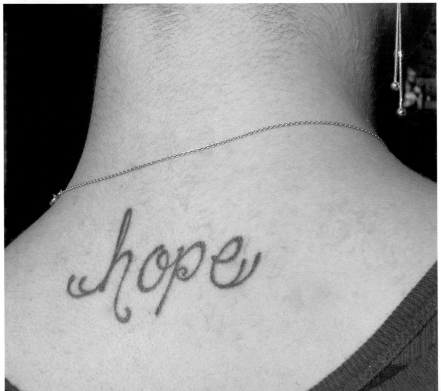

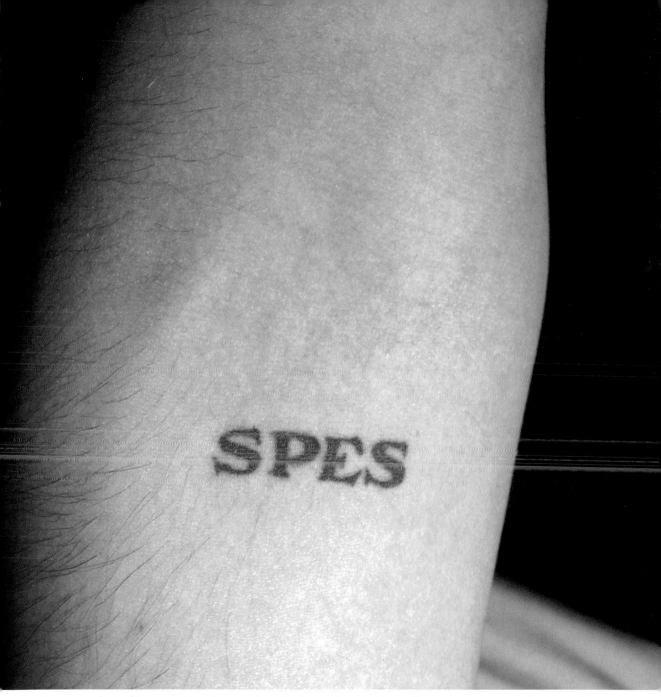

"I am a student of Latin, and 'spes' means 'hope' in Latin. I printed it out from my computer in the size and style I wanted. This is my only tattoo." Opposite: Hope is a popular belief system expressed in tattoo form.

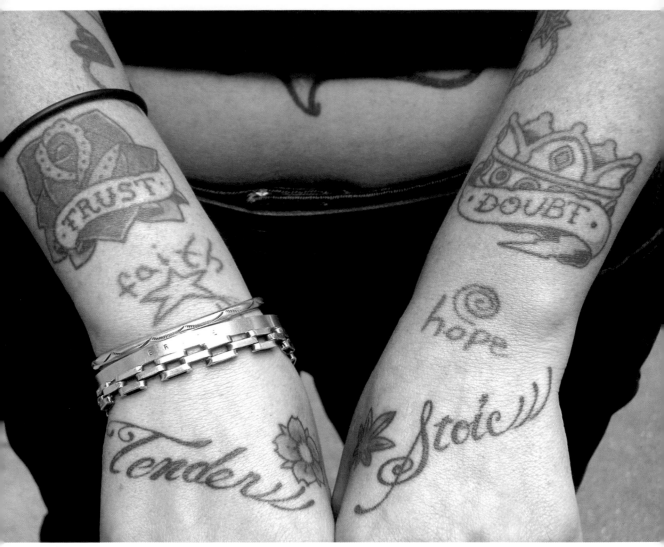

" 'Tender' and 'Stoic' are about how we try to stay present for emotional life events . . . I was finishing graduate school. This is a place where one puts their intimate workings on display, couches them in high art language for protection, then everyone sits around and rips it all apart. 'Hope' and 'Faith' are about Pandora's Box and my changing belief that hope is the most difficult of the evils, not the light emanating from the bottom of the box." Many tattoos come in pairs of beliefs: Opposite, above: "Strength" and "Devotion," along with the logo for the band Black Flag.

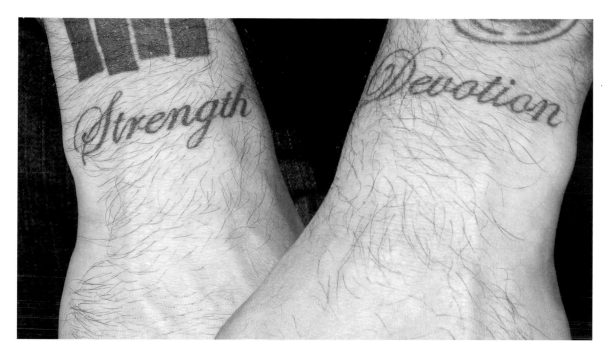

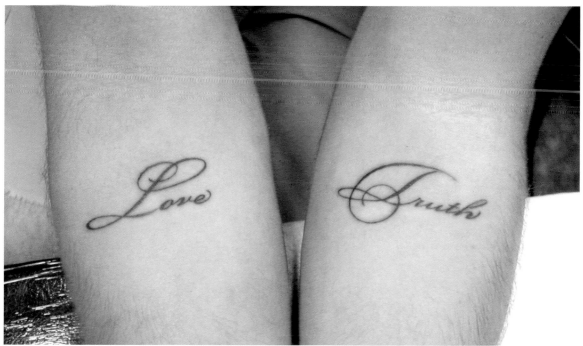

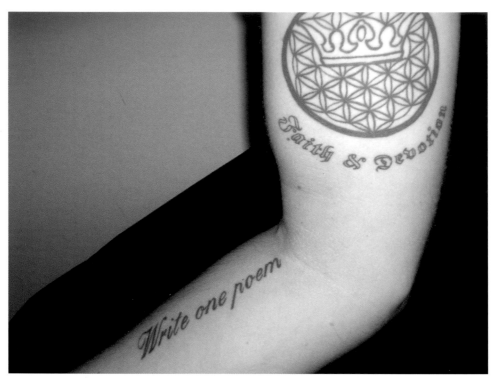

"These are thoughts that inspire me. I studied industrial design, and I am now a creative director in an advertising agency in Vienna."

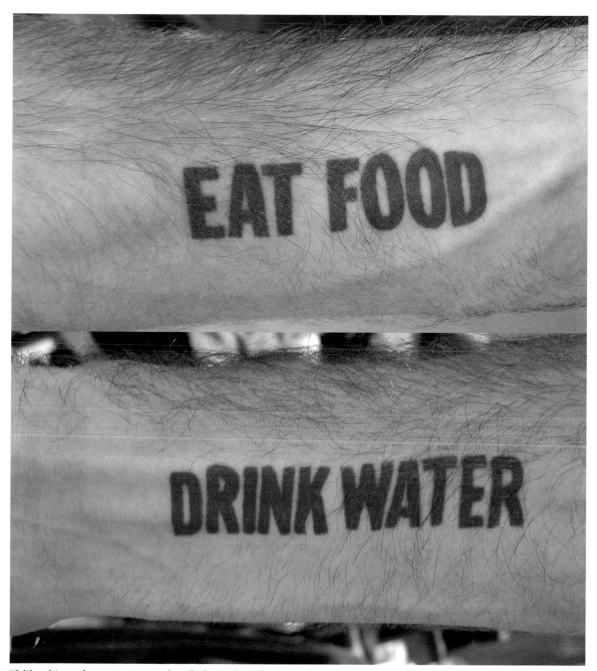

"I like things that are very graphic; I chose these letters and the size. I smoke and drink a lot; I always forget the important things, so my friend told me I needed a reminder."

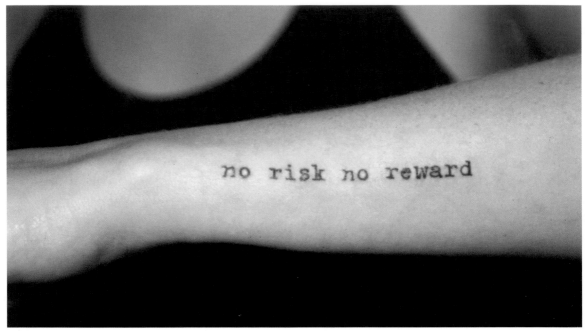

A personal motto in a monospaced typewriter style.

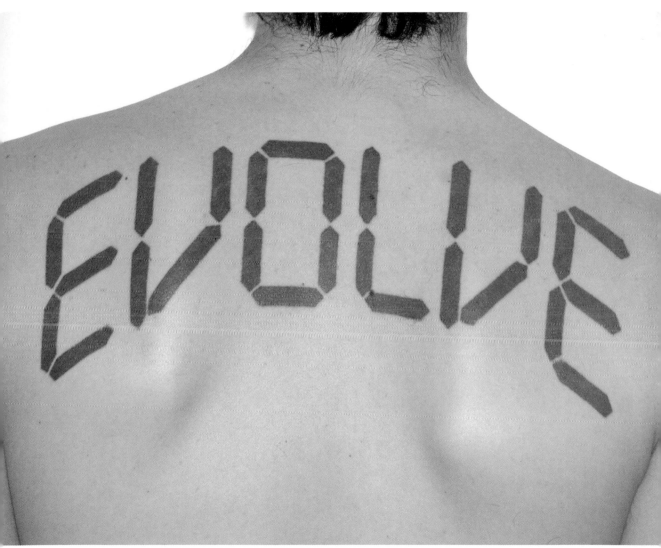

"This was my first tattoo; it represents a personal commitment to evolve, and my general belief in the theory of evolution. The font represents the time we live in, the digital age. Also my belief that technology is evolving to integrate with humans . . . and vice versa."

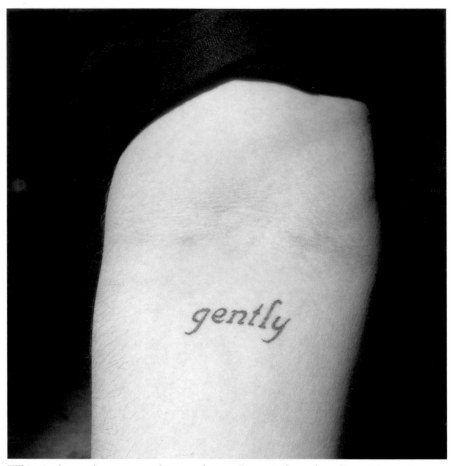

"This single word sums everything up for me. It reminds me how I want to treat others, and how I want to be treated . . . my 'handling instructions.' And it is in the location where I most like to be kissed. I chose the typeface Wedding because it is 'like a whisper.' "

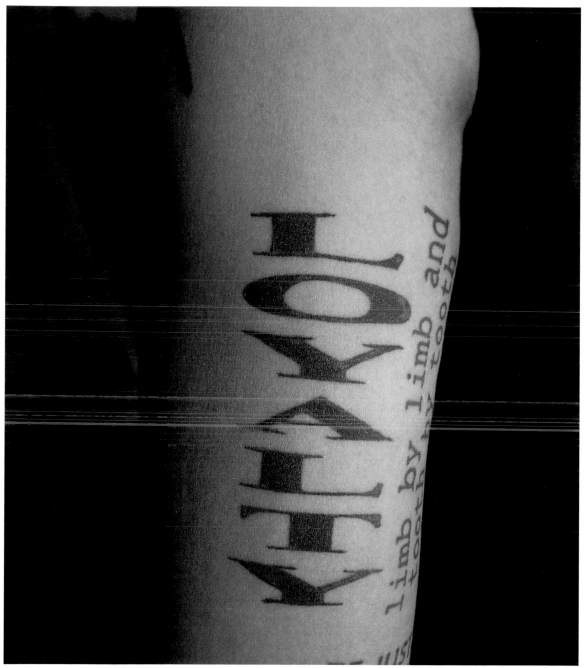

"This is an important belief for me; I chose the lettering and stretched it on my computer to fit in the space."

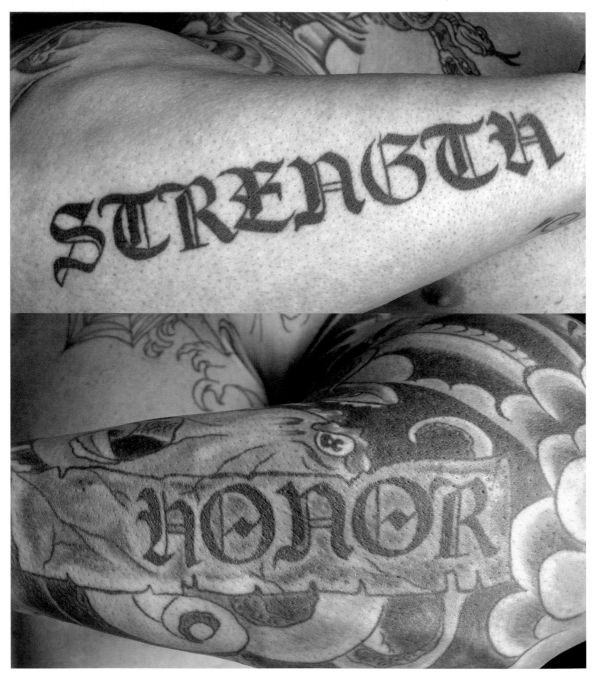

"These are my words of inspiration from the film *Gladiator*."

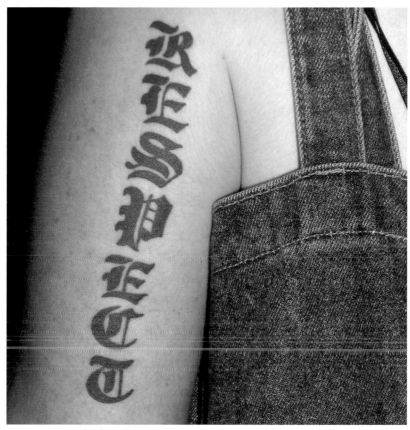

"I wanted it to look and sound tough." Blackletter, like that on this page and the opposite page, was once the commonly used form of writing. To modern eyes, however, there is a "tough" connotation to this lettering style.

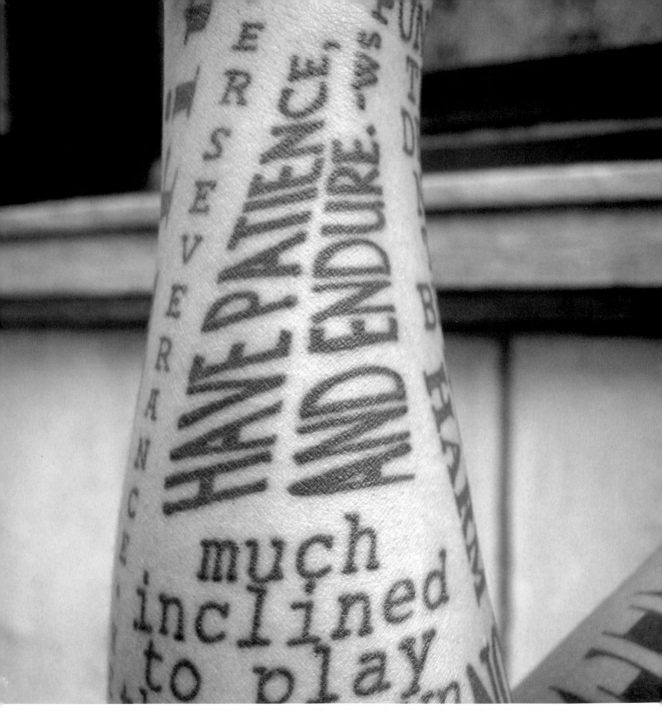

"This is from Shakespeare, one of the many authors whose quotes have moved me and motivated me."

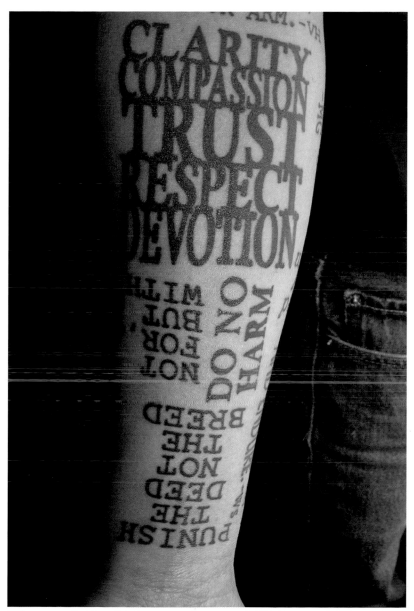

"These are all things I believe in and aspire to. I felt these words belonged together, and I wanted them to be bold, to last as long as possible."

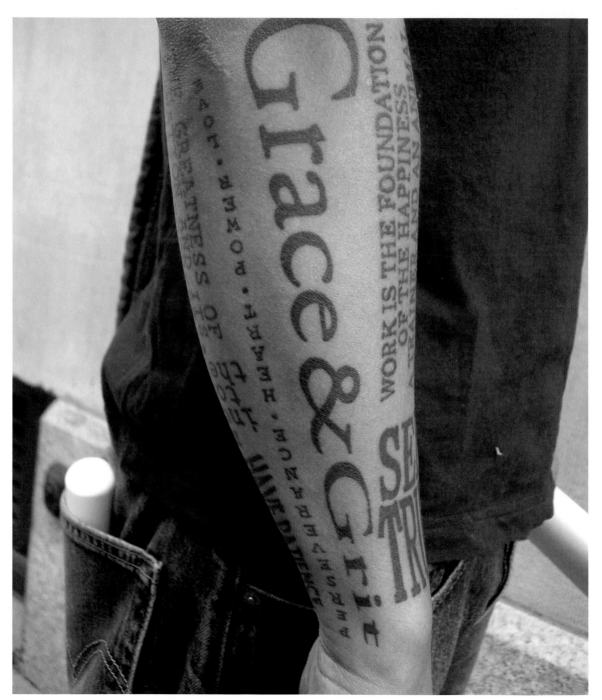

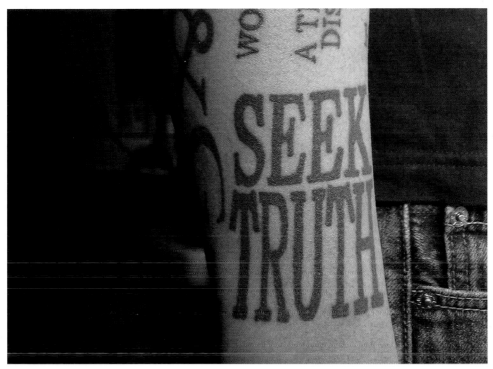

"These are all meaningful and important words to me . . . as my tattoos evolved, I filled a space and was left with a void; so I tweaked the type in Photoshop. I also wanted things going in different directions. I worked closely with the tattoo artist to shape all the type so it would work with my other tattoos. It is important to have a rapport with the artist; someone who understands your intention."

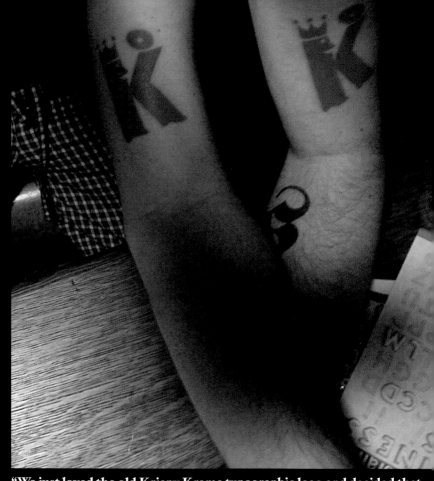

"We just loved the old Krispy Kreme typographic logo and decided that

NINE:
HOMAGE

PAYING TRIBUTE MAY TAKE MANY FORMS, including that of a typographic tattoo. The tattoo represents a desire to connect with the object of devotion by committing to wear its symbol or mark. We may also wish to commemorate a place or an event that is significant in our lives, or to identify with our sports heroes. Companies such as Harley-Davidson and Apple Computer have attained cult status, and tattooed variations of their logos abound.

Especially during wartime, soldiers, sailors, and aviators commonly inscribe themselves with the names of their units, ships, and planes. These tattoos function as talismans against danger as well as pay homage. The tattoos of corporate logos are a more recent phenomenon, representing a bond with a company's philosophy or image, not surprising in a society driven by commercialism and materialism. Designers refer to logos as "marks." These marks are the ultimate tribute, the highest form of brand awareness.

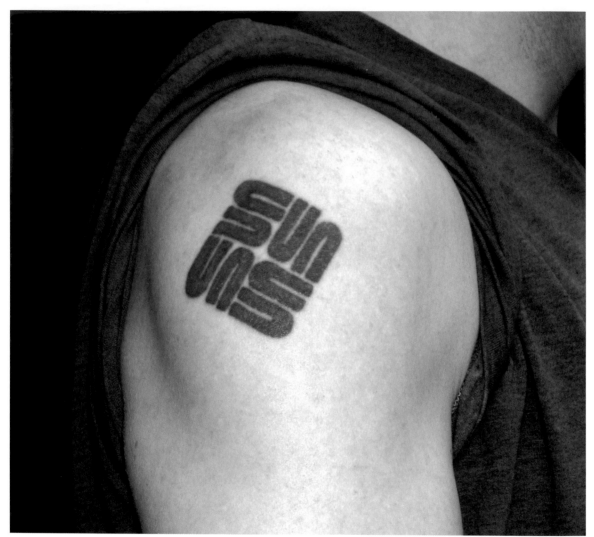

"I had the idea of having my body covered in corporate logos like a race car driver. I had worked in a lab doing programming and I felt close to the processors (especially Sun, which built the microprocessors for the first computer I worked on), so I decided to get the logos of two of the chip manufacturers tattooed on my arms. I went to a computer magazine, made enlarged copies of the logos, and brought the copies to the artist. My next intended tattoo was a Motorola logo. Back then I was going to a lot of clubs and the tattoos were very visible in a tank top. By day I had to wear a suit and tie. Now I work as a lawyer at a patent litigation firm."

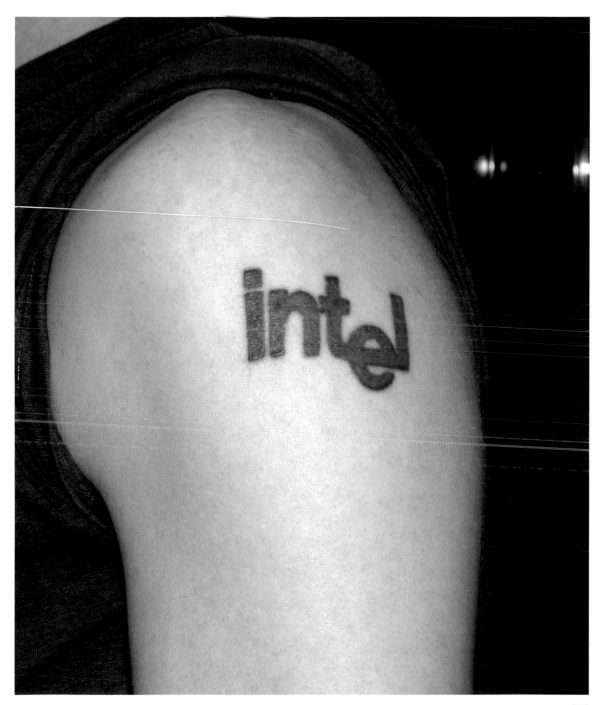

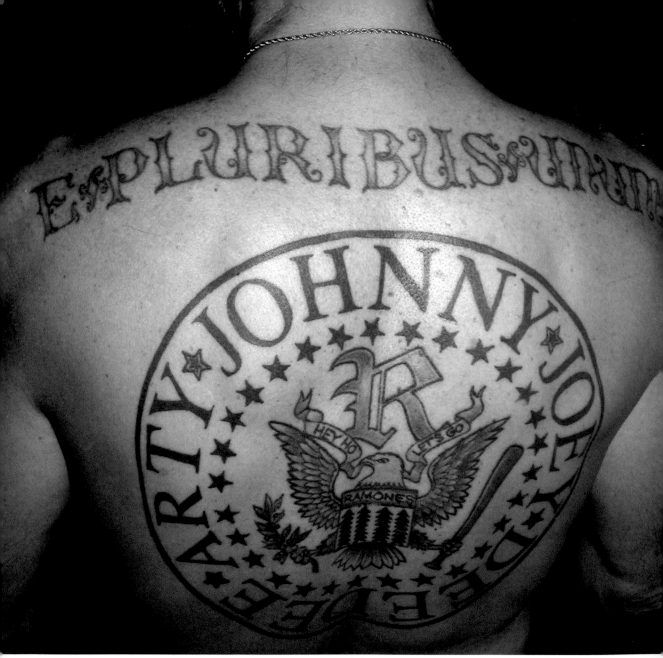

"I was the manager of the Ramones, and I got this tattoo to commemorate my involvement with the band, working my own name into the band's logo. I'm also a painter, and I had made paintings of this special silver dollar which had this lettering ('e pluribus unum'; translation: out of many one) on it, so I decided to get a tattoo of that text as it appears in my paintings."

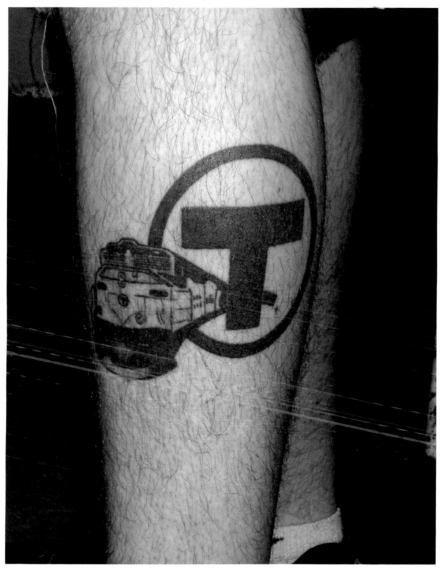

"I'm a printer and graffiti writer, trying to become a tattoo artist. I got this tattoo because I like trains. It is the logo of Boston's Mass Bay Transit Authority."

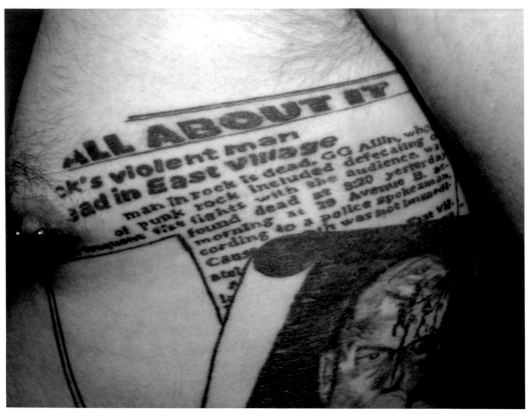

This tattoo replicates the obituary of a punk rocker, G.G. Allin, who died of a heroin overdose.

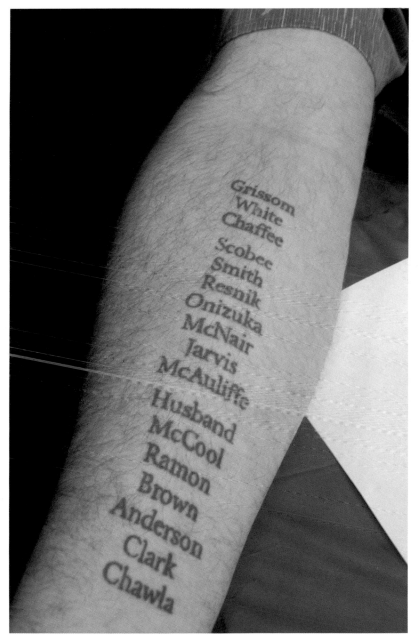

This tattoo pays homage to all of the NASA astronauts who have died in space. The subtle extra leading groups those who perished together. A classic roman typeface lends dignity to this memorial tattoo.

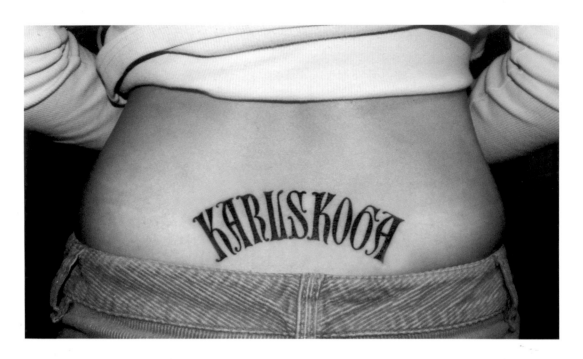

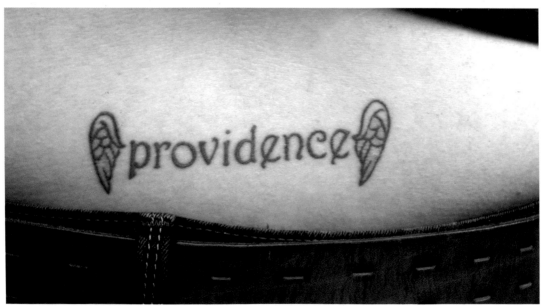

Above: homage to her hometown in Sweden, tattooed in highly attenuated Lombardic caps. Below: homage to Providence, Rhode Island. "I learned most about providence when I was living in Providence."

178

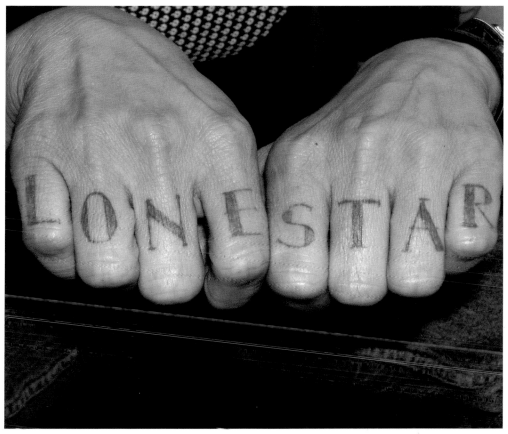

The hands of a New York City tattoo artist who specializes in typographic tattoos. She is from Texas, and this was her first tattoo, a simplified variation of the "Sailor Jerry" style.

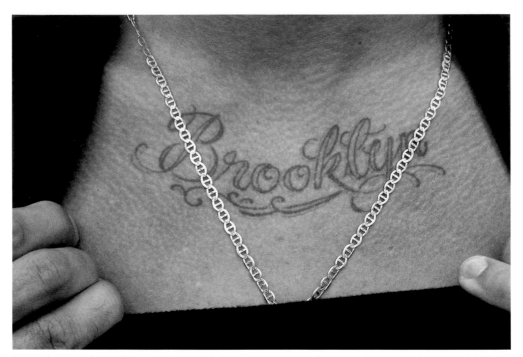

"I was born and raised in Brooklyn, and that's not going to change. When I'm fifty years old I'll still be from Brooklyn."

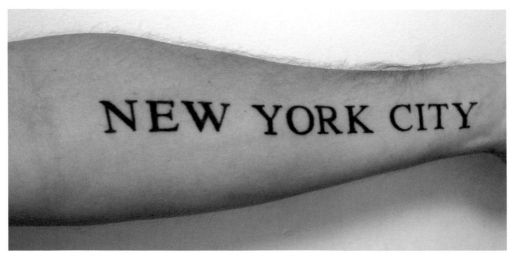

"I love New York City . . . it never disappoints. I chose Times New Roman for its simplicity."

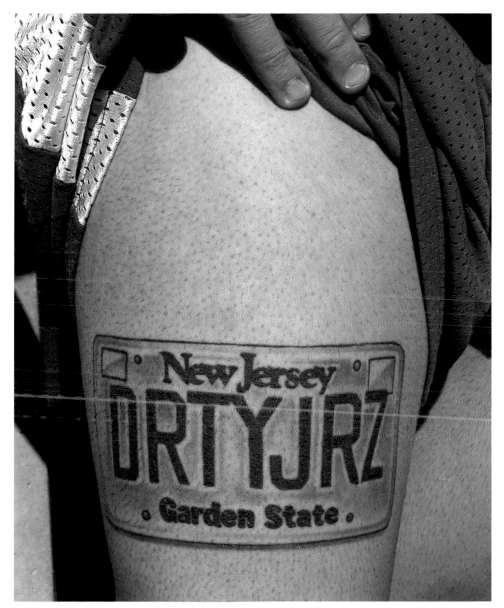

"I designed this with the artist; he took the license plate off his car and freehanded it. I'm a big Jersey guy, proud of where I came from. I'll never forget my roots."

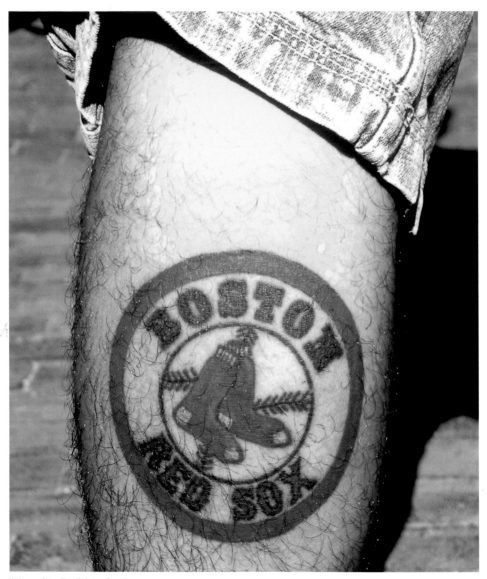

"I'm a big Red Sox fan."

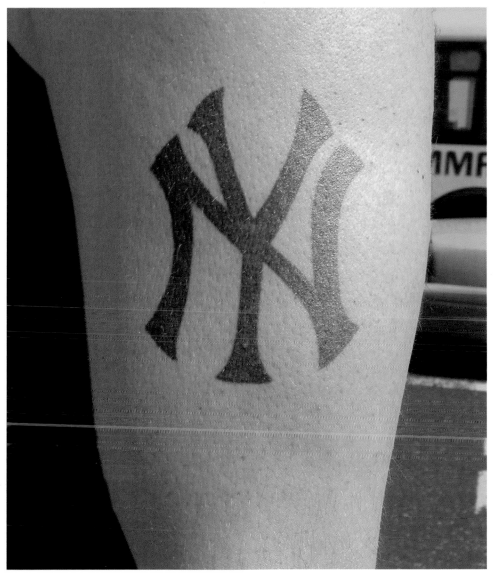

"I'm a big Yankees fan."

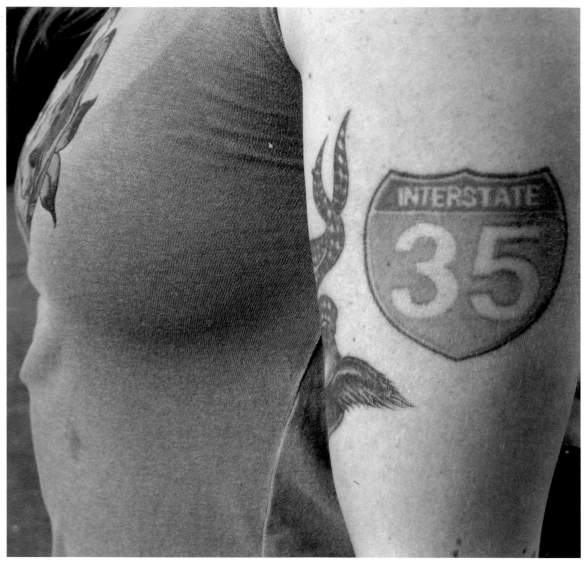

"Great memories of a trip I took."

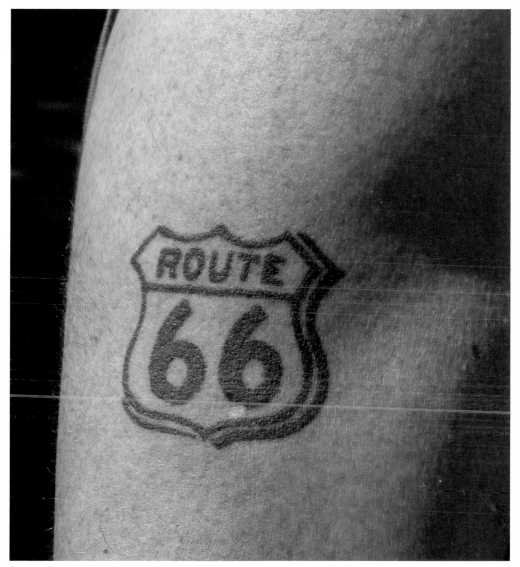

"When my wife and I visited the U.S. (we are Australian) we loved driving on the legendary Route 66."

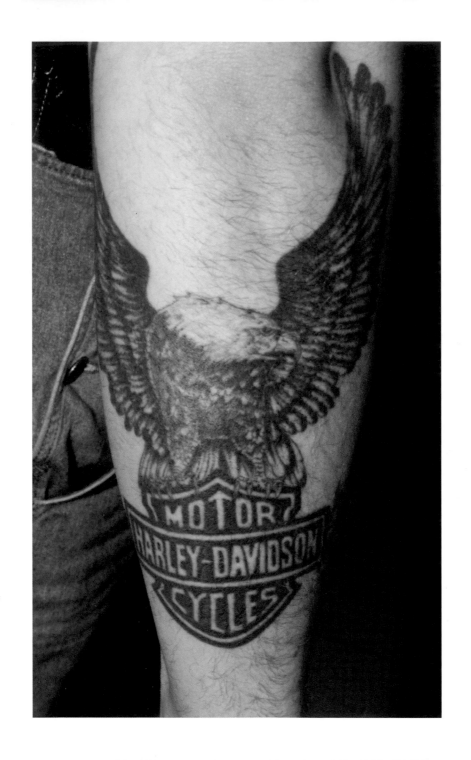

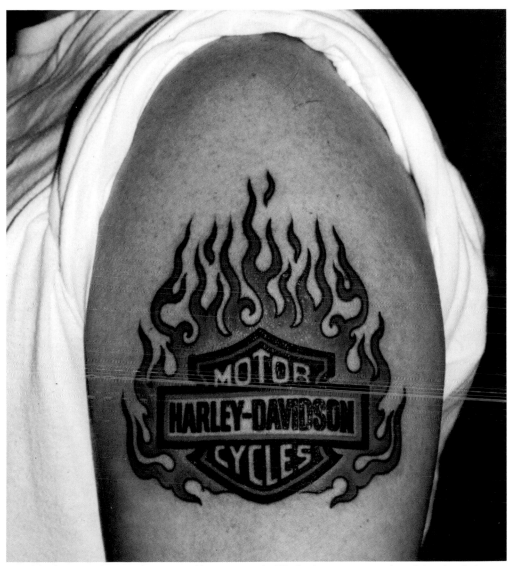

Possibly the most frequently tattooed logotype is the Harley logo; tattoo artists claim that it is one of the hardest typographic forms to tattoo, because the letterforms are very narrow and tightly spaced. "There's just no room for error."

THE ONES THAT GOT AWAY...

... (though I pursued them): the young woman at Fifth
Avenue and 86th Street with "dry clean only" tattooed on
her right shoulder; the rocker from Ann Arbor with the lengthy
Richard Brautigan quotation on her upper back; the author from
Philadelphia whose inner forearms bear the white text tattoos
"courage" and "compassion"; the guy in the New York City subway
with the giant exclamation point tattoo; the Yankee fan with her
social security number tattooed in binary code on her torso. I
think of you with longing for what might have been.

ACKNOWLEDGMENTS

THIS BOOK COULD NOT HAVE HAPPENED without the encouragement and belief of many friends and colleagues. Thanks to Emily Potts, my editor at *STEP Inside Design* magazine, for allowing me to indulge my curiosity about typographic tattoos in one of my columns. Thanks to Ann McGettigan, who first suggested that I expand my article into a book, and who gently but regularly inquired about my progress. I owe a particular debt of thanks to my good friend Mirko Ilic, whose faith in my idea inspired me to persevere, and whose sense of humor and aesthetic judgment at several key stages was most helpful.

Donald Partyka also provided invaluable creative guidance, especially in structuring the material. I have always had complete faith in Donald's typographic and design sensibilities and in his visual acuity.

Thanks to Mark Gompertz and to the indomitable Jackie Meyer, my friends in the book publishing business, for their sage advice and encouragement. (Early on, Mark allowed, "I think you've got something there.")

Amber Sexton spent a great deal of time and effort helping with photo research for the book; I thank Amber for her talent and generosity.

Thanks to the president and CEO of Harry N. Abrams, Inc., Michael Jacobs, who delighted me with his surprising enthusiasm for my book; and to my savvy editor, Tamar Brazis, who not only allowed me to photograph her own tattoo but led me to some new and quite extraordinary examples of typographic tattoos.

My oldest and dearest friend, Robin Tarnoff, provided critical support during a most difficult time in my life. Without her I would not have had the strength to forge ahead with this project. I owe her more than I can repay; her friendship continues to sustain me.

My running partner, Sally Koslow, devoted much time during our thrice-weekly jogs around the Central Park Reservoir to discussions about my project; I thank her for her writing advice and her common sense.

It is important that I mention others who encouraged me in many ways throughout the book's progress: Ruth McCullough; Jessica Weber; Ruth Marten; Jan Rifkinson; my wonderful in-laws, Rae and Paul Beispel; Daniéle Menache; Carol Wahler; Will Hopkins and Mary Kay Baumann; Eric Rayman; Renee Darvin; Annette Weintraub; Debbie Ullman; Karjean Levine; and Urshula Barbour. Former editorial colleagues who continue to be role models for me are Claudia Wallis and Gretchen Morgenson.

To InaNet subscribers and others who assisted me in my quest to identify and photograph typographic tattoos: Though you are too numerous to mention individually, I am grateful for your detective work; many of your "finds" are represented in these pages.

Among the many tattoo artists whose work appears in this book, Stephanie Tamez from New York Adorned deserves special mention for her lettering skill and her love of letterforms as a means of graphic expression.

To all those whose tattoos I have documented and who have shared intimate details of the meanings of their messages, I thank you for your willingness to bare both your skin and your thoughts for this book. Special thanks to Dan'l Linehan, whose tightly kerned lowercase Helvetica "happy" tattoo (page 107) first caught my attention and who blogged about our brief encounter on the crosstown bus.

Finally, thanks to my husband, Steven Beispel, for his creative imagination (*EpicDermis*!) and for all his help with my research, including accompanying me to various tattoo conventions and photo sessions. I love you.

CREDITS

(Photographs are by Ina Saltz unless otherwise credited; wherever known, artists, designers, and photographers have been credited)

p 12: PHOTOGRAPHER *Chris Luttrell*

p 14: ARTIST AND PHOTOGRAPHER *Stephanie Tamez*

pp 16–17: PHOTOGRAPHER *Reyes Melendez*

p 20: PHOTOGRAPHER *Karjean Levine*

p 21 (top): ARTIST *Midas*

pp 22–23: PHOTOGRAPHER *Mark Fong*

p 24: ARTIST AND PHOTOGRAPHER *Stephanie Tamez*

p 25: ARTIST *Marcus Pacheco;* PHOTOGRAPHER *Scott Mackie*

p 27: ARTIST *Lil Joe*

pp 28–29: ARTIST *Koré Grate;* PHOTOGRAPHER *Suzanne Szucs*

pp 30–31: ARTIST *Stephanie Tamez*

p 33: ARTIST AND PHOTOGRAPHER *Stephanie Tamez*

p 34: ARTIST *Tabare Grazioso* PHOTOGRAPHER *Shelley Jackson*

p 36 (top left): PHOTOGRAPHER *Marno*

p 43: DESIGNERS *Tony and Caio de Marco;* ARTIST *Luciano BarrioNuevo*

p 49: ARTIST AND PHOTOGRAPHER *Todd Tauscher*

p 51: ARTIST *Troy Denning*

p 54: DESIGNER *John Langdon;* ARTIST *Karl Kegess;* PHOTOGRAPHER *Andrew King*

p 56: DESIGNER *John Langdon;* ARTIST *Scotty Lowe*

p 57: DESIGNER *John Langdon;* ARTIST *Steve Andres*

p 58: DESIGNER *John Langdon;* ARTIST AND PHOTOGRAPHER *Stephanie Tamez*

p 59: DESIGNER *John Langdon;* ARTIST *Scott Padget;* PHOTOGRAPHER *Bruce Barone*

p 60: ARTIST AND PHOTOGRAPHER *Stephanie Tamez*

p 62: ARTIST AND PHOTOGRAPHER *Stephanie Tamez*

p 64: ARTIST AND PHOTOGRAPHER *Nick Colella*

p 68: ARTIST AND PHOTOGRAPHER *Nick Colella*

p 75: ARTIST *JC*

p 80: PHOTOGRAPHER *Tom Schierlitz*

p 81: ARTIST AND PHOTOGRAPHER *Mike Bellamy*

pp 83–84: ARTIST AND PHOTOGRAPHER *Nick Colella*

p 85: ARTIST AND PHOTOGRAPHER *Stephanie Tamez*

p 88: ARTIST AND PHOTOGRAPHER *Stephanie Tamez*

p 89: ARTIST *Troy Denning*

p 90: ARTIST AND PHOTOGRAPHER *Stephanie Tamez*

p 91: PHOTOGRAPHER *Emilie Zoey Baker*

p 93: DESIGNER *David Feiner*

p 94: DESIGNER AND PHOTOGRAPHER *Ariel Cepeda*

p 95: DESIGNER *Patrick Ojeda*

p 96: DESIGNER *Aaron Goodstone*

p 97: ARTIST AND PHOTOGRAPHER *Nick Colella*

p 98: ARTIST *Nick Colella*

p 99: DESIGNER *Margot Chase*

p 100: ARTIST *Eric Mermagen;* PHOTOGRAPHER *Karjean Levine*

p 102: DESIGNER *Arturo Vega*

p 107: DESIGNER *Dan'l Linehan*

p 110 (top right): ARTIST AND PHOTOGRAPHER *Stephanie Tamez*

p 114: ARTIST AND PHOTOGRAPHER *Stephanie Tamez*

p 116: ARTIST *Greg Bellanger*

p 117: ARTIST *Leon Ridbout*

p 118: PHOTOGRAPHER *Reyes Melendez*

pp 121–122: PHOTOGRAPHER *Karjean Levine*

pp 124–125: PHOTOGRAPHER *KarjeanLevine*

pp 126–127: ARTIST *Henk Schiffmacher;*

PHOTOGRAPHER *Frank Hanswijk*

p 130: ARTIST *Todd Vargas;* PHOTOGRAPHER *Karjean Levine*

p 132: PHOTOGRAPHER *Karjean Levine*

p 136: PHOTOGRAPHER *Karjean Levine*

p 138: PHOTOGRAPHER *Karjean Levine*

p 139: ARTIST AND PHOTOGRAPHER *Stephanie Tamez*

p 140: DESIGNER *Kiel A. Scott*

p 141: ARTIST AND PHOTOGRAPHER *Stephanie Tamez*

p 142: ARTIST *Katja O;* PHOTOGRAPHER *Nicole Dallis*

pp 144–145: DESIGNER *Brian Bonislawsky*

p 149: ARTIST AND PHOTOGRAPHER *Stephanie Tamez*

p 153: ARTIST AND PHOTOGRAPHER *Iggy Vans*

p 154 (top): ARTIST *Mondo*

p 156: (tender/stoic; trust/doubt) ARTIST *Colin Stevens*

p 157 (top): ARTIST *Robert Bonhomme* *(bottom):* ARTIST AND PHOTOGRAPHER *Stephanie Tamez*

p 160: ARTIST AND PHOTOGRAPHER *Mike Bellamy*

p 161: ARTIST *Mike Giant;* PHOTOGRAPHER *Nicole Dallis*

p 163: ARTIST *Stephanie Tamez*

p 166–169: ARTIST *Stephanie Tamez*

p 174: DESIGNER *Arturo Vega;* ARTIST *Darren Rosa*

p 176: ARTIST *Eric Mermagen* PHOTOGRAPHER *Karjean Levine*

p 177: PHOTOGRAPHER *Joe Miller*

p 178 (top): ARTIST AND PHOTOGRAPHER *Iggy Vans*

p 180 (bottom): PHOTOGRAPHER *Rony*

p 181: ARTIST *Jay Sall*

p 186: ARTIST AND PHOTOGRAPHER *Janos Masz*

p 187: ARTIST AND PHOTOGRAPHER *Iggy Vans*

INA SALTZ is an art director, designer, writer, and professor whose areas of expertise are typography and magazine design. She is a regular columnist for *STEP Inside Design Magazine* and writes for other design magazines, including *Graphis*.

Ina is an associate professor in the Electronic Design and Multimedia Program at the City College of New York. She is also on the design faculty of the Stanford Professional Publishing Course, where she lectures on magazine design and hosts webcasts on effective typography.

She lives in New York City with her husband. She has no pets or tattoos, but she does have favorite typefaces (Requiem, Franklin Gothic No. 2) and favorite characters (&, Q, Z, R). *Body Type* is her first book.

TATTOO & TATTOO TATTOO

TATTO TATTOO TATTOO

TATTOO *Tattoo* TATTOO HANNA

TATTOO TATTOO SHOP TATTOO

TATTOO TATTOO & BODY PIERCING TATT

TATTOO TAT TATTOO